FOCUS ON

digital photography basics

FOCUS ON
digital photography basics

Jeff Wignall

LARK
PHOTOGRAPHY
BOOKS

A Division Of Sterling Publishing Co., Inc.
New York / London

Editor: Matt Paden
Book Design: Tom Metcalf
Cover Design: Thom Gaines

Library of Congress Cataloging-in-Publication Data

Wignall, Jeff.
 Focus on digital photography basics / author, Jeff Wignall. – 1st ed.
 p. cm.
 Includes index.
 ISBN 978-1-60059-639-1
 1. Photography–Digital techniques. I. Title.
 TR267.W5395 2010
 775–dc22
 2009043784

10 9 8 7 6 5 4 3 2

Published by Lark Books, A Division of
Sterling Publishing Co., Inc.
387 Park Avenue South, New York, N.Y. 10016

Text © 2010, Jeff Wignall
Photography © 2010, Jeff Wignall, unless otherwise specified

Distributed in Canada by Sterling Publishing,
c/o Canadian Manda Group, 165 Dufferin Street
Toronto, Ontario, Canada M6K 3H6

Distributed in the United Kingdom by GMC Distribution Services,
Castle Place, 166 High Street, Lewes, East Sussex, England BN7 1XU

Distributed in Australia by Capricorn Link (Australia) Pty Ltd.,
P.O. Box 704, Windsor, NSW 2756 Australia

If you have questions or comments about this book, please contact:
Lark Books
67 Broadway
Asheville, NC 28801
(828) 253-0467

Manufactured in China

ISBN 10: 1-60059-639-1

For information about custom editions, special sales, premium and corporate purchases, please contact Sterling Special Sales Department at 800-805-5489 or specialsales@sterlingpub.com. For information about desk and examination copies available to college and university professors, requests must be submitted to academic@larkbooks.com. Our complete policy can be found at www.larkbooks.com.

Contents

Introduction

Back in the 1960s, when I was a teenager and spent most of my time either shooting pictures or hiding in my darkroom (and at 15, having a great place like a darkroom to hide was reason enough to take up photography), we put a lot of stock in concise philosophies. Much of the cherished wisdom of the ages was rediscovered and reduced to a ten-word declaration and published boldly on Dayglo bumper stickers. One of the more popular bits of wisdom (and it was plastered on almost every VW bus in sight) proclaimed, "The journey of a thousand miles begins with a single step."

Corny as it might have seemed (especially to our very un-hip parents), when you saw it 50 times a day driving down the highway, it was—and remains—a very valid concept of learning. You learn something new by taking the initiative to begin, to seek knowledge, and to gather experience. You learn by doing, by putting one foot ahead of the other on the road to discovery.

No one is born knowing how to take great pictures. You might have, as they say, an "eye" for seeing a good picture, or you might be a techie sort of person that has an instinct for using digital cameras or computers. But as with any passion or hobby, success comes from practice, study, experimenting, and commitment.

If this is your first photography book, then let this be your first step. I've tried to write it in a way that presupposes almost no knowledge of or experience with digital cameras, computers, or even picture taking. It is, as the title implies, a basic guide that hopefully will help you take that first step to a long and creative journey.

The interesting thing about any journey, of course, is that you often get so distracted by the twists and turns along the way that you forget how much progress you're making. It's only when you've been walking a while and turn to look back that you see just how far you've come. By the time you finish this book you will be much further down the path to the joy of taking great pictures than you might imagine. So turn the page, take that first step, and let the journey begin.

Digital Camera Basics

I n order to shoot, edit, and print digital photos, you'll need just four things: a digital camera, image-processing software, a computer, and a photo-quality inkjet printer. But, since there are labs that can edit and print your photos for you, all you really need to get started is a digital camera. While the technology surrounding digital cameras might make them seem daunting at first, digital cameras are very similar to the film cameras of the past. Sure, digital cameras might seem more complicated, but in the end they have significantly improved and actually simplified the picture-taking process. Let's take a look at the basics.

Digital cameras offer a whole new photography experience for those accustomed to film. Now, instead of taking a picture and hoping you got the shot, you can simply review the LCD screen and continue shooting until you get the image you want. The instant feedback makes learning from your mistakes and successes a much more intuitive process.

Exposure mode: Aperture Priority
Focal length: 280mm
Aperture: f/8
Shutter speed: 1/70
White balance: Auto
ISO: 100

1.1 Digital Cameras

Inside a Digital Camera

All cameras consist of three common elements: a lens (for gathering and focusing light), a dark box (where the light is focused), and some means of storing that light—which in the case of digital cameras is a tiny computer chip, or sensor—that records the image. Two different types of chips are used in digital cameras: either a CCD (charged couple device) or a CMOS (complementary metal oxide semiconductor). Both types of chips use a veritable forest of miniature electronic circuitry to convert light images to digital signals that your computer can interpret and display as photographs.

Camera Types

If you've spent any time flipping through photo magazines or window shopping at the camera store, you know that digital camera choices multiply like digital rabbits. Essentially though, all of these cameras can be placed into one of these three loosely defined groups: compact digital cameras (point-and-shoot), advanced digital zoom cameras, and digital SLR (single-lens-reflex) cameras, also called D-SLRs. Each type of camera has its own unique advantages, and in the following pages we'll take a look at each of these three groups.

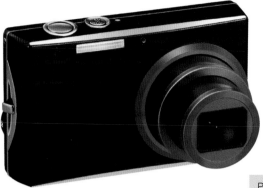

Point-and-shoot camera

Compact Digital Cameras: If simplicity, ease-of-use, and small size are high on your list of important camera qualities, then compact digital point-and-shoot cameras were made for you. Typically, these cameras provide fully automatic exposure and focus, a built-in flash, and a modest 3x optical zoom lens in a package that's smaller than a deck of playing cards. (See page 39 for more about optical zoom.) Most compact digital cameras have both an optical viewfinder and an LCD monitor that can be used to compose your pictures. These cameras also usually come with a built-in flash. While many offer a variety of exposure scene modes (see page 62 for details), most lack the more sophisticated exposure controls that advanced digital zoom cameras and D-SLRs offer. That said, there are a few models out there that mimic the capabilities of D-SLRs, just minus the interchangeable lenses. These options usually offer full exposure control, a hot shoe for off-camera flash, and even shooting in the RAW file format. These are perfect for the savvy photographer who doesn't always want to lug a D-SLR around.

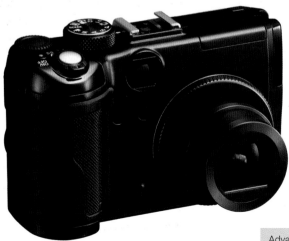

did u know?
Advanced compact digital cameras offer almost all of the features of a D-SLR minus the interchangeable lenses.

Advanced compact

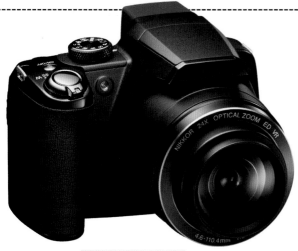

Digital zoom camera

Advanced Digital Zoom Cameras: These cameras provide many of the professional exposure and metering options that digital SLR cameras offer, while maintaining the shooting ease and simplicity of compact digital cameras. Many of these cameras offer TTL (through-the-lens) viewing—you see exactly what the lens is seeing when you look through the optical viewfinder. Also, many have much more extensive optical zoom ranges (up to 12x), but unlike D-SLR cameras, they don't have interchangeable lenses. These cameras are designed for serious hobbyists who want more in the way of exposure control and optical flexibility than basic compact digital cameras can offer.

Digital SLRs: Digital SLR (D-SLR) cameras represent the pinnacle of both technical and creative control in the digital camera family, and they offer one feature that no other type of digital camera provides: the ability to change lenses. This unique feature puts the entire range of camera lenses, from ultrawide angles to super telephotos, literally at

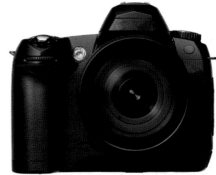

Digital SLR

your fingertips (provided your pockets are deep enough to support such a luxury). Also, D-SLRs use a complex system of mirrors and prisms (as opposed to the ELF electronic display in some point-and-shoot and compact zoom cameras) so that what you see in the viewfinder is exactly what the lens is seeing—which can be a very big creative advantage. D-SLRs used to not offer the option to compose images on the LCD screen, but in the last few years most models have begun to offer Live View technology. Simply put, D-SLRs offer the most extensive range of metering and exposure controls, as well as access to a mindboggling range of accessories.

1.2 Try Before You Buy

Buying a new digital camera can seem like an overwhelming process when there are so many models out there with so many different features. Use the following guide to help with the selection process.

Megapixels: Resolution mainly affects how big your images will be, both on the computer and in print (see page 22). More megapixels will capture more details, but unless the photo is made into a large print, they might never be seen. Usually the higher-megapixel cameras offer more advanced features, so even if you don't need the high resolution, you may want the other options a higher-megapixel camera offers.

LCD Monitor: This important feature is what makes the digital photography experience work so well. These days, most LCD monitors are large and bright. Still, you'll want to be sure your LCD is a good size, has decent brightness and contrast, shows good color, and is easy to view. The LCD monitor is how you will evaluate your images and interact with your camera's menus and features—so make sure you like it. Also, if buying a D-SLR, check to see if it offers Live View if composing on the LCD screen is important to you.

did u know?
Some D-SLR cameras offer flip-out LCD screens, which are ideal for composing images from hard-to-see angles.

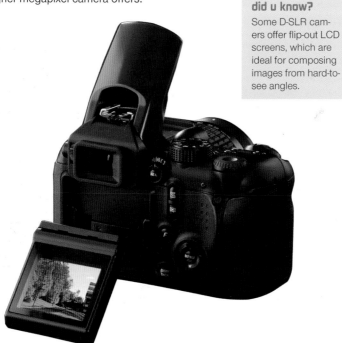

did u know?

It makes a lot of sense to try out many camera during the buying porcess. You want to make sure you buy one that feels natural and has logical controls.

Handling: This is an extremely important part of a camera selection process. You really have to hold the camera, try the controls, and see how it feels. A chart of features will never supply this information. If you don't like the way a camera feels or handles, you probably won't enjoy using it and won't take it with you as often.

Ease of Use: Controls from one digital camera to another are neither consistently placed, nor are operations controlled by a uniform set of dials or buttons. Since we all handle cameras in different ways, how controls are accessed for logical operation is important. Are they easy to find and use? Check to be sure the menus are clear and easy to read as well.

The Camera System: Various manufacturers of digital cameras offer different choices of add-on lenses, adapters, flash units, and other accessories. Different brands of D-SLRs offer a variety of approaches to similar accessories. Before deciding upon a particular brand, make sure the accessories you need are available and in your price range.

did u know?

Consider the extras before choosing your camera body because you are buying into a whole system of lenses, adapters, and flashes. Make sure your camera manufacturer has the accessories you want at the right prices.

The Sensor: This is the light-sensitive part of the camera that reads the scene as focused by the lens. Some small, compact digital cameras have megapixel specs that are similar to or higher than some D-SLRs. However, these smaller cameras feature physically smaller sensors than those found on D-SLRs. Small sensors have less exposure latitude and potentially exhibit more noise. It is harder to get a clean, noiseless image from a small camera, especially with low light and high ISO settings (more on this on page 56). However, in good conditions with low ISO settings, these cameras can offer images that rival much larger cameras.

Boot-Up Time: This is the length of time it takes after a camera is turned on until it is actually ready to shoot an image. This is important so you don't miss images waiting for the camera to turn on.

Lag Time: Lag time is the delay between pressing the shutter release and when the camera actually goes off. This period varies tremendously among digital cameras. A long lag time can cause you to miss potential photos because the subject might change in the time between when you release the shutter and when the image is actually recorded.

Buffer and Processing: Processing determines how fast a camera can capture the data from the sensor and move it to the internal buffer, where it is stored until the camera automatically downloads it onto the memory card. This will be expressed in frames per second (fps). Once the camera's internal buffer is full, the camera must stop taking pictures until space is opened up by transferring data to the memory card. Having a camera that shoots a high amount of frames per second is important if shooting sports or other fast-moving subjects is important to you.

HD Video: Most small digital cameras offer a great bonus—High Definition (HD) video capture. These days, even many new models of D-SLRs are starting to offer this feature. Some new camera models also offer a web-optimized option that records video in the best format for uploading and viewing on the Internet. An important factor in video resolution is file size—the lowest resolution makes videos that take up considerably less space on your memory card or hard drive. While HD video is nice to have as an option, you'll need to invest in large memory cards (4GB and up is best) to get anything more than a couple of minutes of footage. Although the video technology in digital cameras is not yet as sophisticated or convenient as a camcorder, it's improving all of the time, and it does offer the chance to capture short video snapshots without having to lug around two pieces of gear.

Photo © Matt Paden

Exposure mode: Shutter Priority
Focal length: 55mm
Aperture: f/4.5
Shutter speed: 1/100
White balance: Auto
ISO: 100

1.3 Making Sense of Megapixels

One of the main ways that digital cameras are described is in terms of their resolution, or how many pixels they have. As mentioned earlier, the amount of megapixels offered is also an important buying consideration. Cameras with more pixels (theoretically, at least) take sharper-looking pictures with better tonal gradations and richer colors.

Pixels and Megapixels

Of course, talking about pixels naturally begs the question: What exactly is a pixel? The sensor in your digital camera (which is about the size of a dime in most cameras) is made up of millions of microscopic light-gathering cells called photosites or, more commonly, pixels (short for "picture elements"). A camera's resolution capability is measured in megapixels, or millions of pixels. A 10-megapixel camera, for instance, has roughly 10 millions pixels on its sensor.

How Pixels Work

If you've ever looked at a pointillist painting by the artist Georges Seraut, you already have a good idea of how the pixel concept works. Each pixel captures and records a separate point of brightness and color. Using a visual blending system that is very much like that used by Seraut and other pointillist painters, digital cameras turn these millions of dots of light into very realistic photographs.

How Many Pixels Do You Need?

Generally, the more megapixels a camera has, the better its image quality will be, and the more expensive the camera will be. Pixels alone don't define digital image quality, but just as with a pointillist painting, the more dots the artist uses (or the more pixels the camera uses) the subtler the transitions between colors and tones will appear. The

did u know?
The sensor is the light-sensitive medium within a digital camera that captures images. Generally, a larger sensor equates to sharper and larger pictures.

number of megapixels you record an image with will also determine the maximum size print you can make. These days, even most entry-level cameras offer at least 10-megapixels, which is more than enough for the average shooter. 10-megapixel cameras allow for printing images at 8.5 x 13 inches (21.6 x 33cm) at 300 dots per inch (more on this in a moment). Many amateur shooters would be well-advised to stay in the 10-megapixel camera range. Buying a larger megapixel camera will increase the storage demands on memory cards and computer hard drives.

did u know?

Cropping is one of the greatest benefits offered by today's high megapixel cameras. With a large sensor you can crop in quite close on your subjects and still have a large enough image for printing.

Exposure mode: Auto
Focal length: 105mm
Aperture: f/7.1
Shutter speed: 1/800
White balance: Auto
ISO: 200

1.4 What is Resolution?

Exposure mode: Aperture Priority
Focal length: 45mm
Aperture: f/9
Shutter speed: 1/320
White balance: Auto
ISO: 200

Digital pictures are also often described in terms of their image resolution, or the number of pixels a particular picture has both horizontally and vertically. For example, a picture made with a 10-megapixel camera could be described as having a resolution of 3651 x 2739 pixels. What this means is that there are 3651 pixels across the long dimension of the image, and 2739 on the shorter dimension. If you were to multiply those numbers together, you would get roughly 10,000,000 pixels—or 10 megapixels.

More About Resolution

One topic that you simply can't escape from in digital photography is resolution. The problem is that, in the digital world, there are several different kinds of resolution. The three main types of resolution that you will encounter are camera resolution, image resolution, and print resolution. Here are some simple explanations:

Camera Resolution: Camera resolution is measured in terms of the total number of pixels that a camera is capable of recording an image with, as in the 10-megapixel example we just looked at.

Image Resolution: Images displayed on your computer monitor have a resolution that's measured in a different way. Image resolution is described in terms of ppi, or pixels per inch. In other words, image resolution describes how many pixels exist per inch of the image on the computer screen. Typically, website images, for example, are displayed at 72 ppi, or 72 pixels per linear inch of screen.

Print Resolution: Printer resolution is described in terms of dpi, or dots per inch, and refers to the number of microscopic droplets of ink per linear inch of printing surface. The standard for high-quality prints is 300 dpi.

did u know?

Using the correct resolution for your prints is important or they will look very pixilated (meaning subjects will appear rough with jagged edges). Make sure your images are saved at 300dpi before you print them.

Note:

Despite the important differences between image resolution and print resolution, you should be aware that many people commonly refer to both image resolution and print resolution in terms of dpi.

1.5 Capture the Magic
on Memory Cards

Once your digital camera has captured an image, it needs a place to store that image so that it can get ready to take more pictures. Memory cards are small computer chips that slip into your camera and can hold anywhere from a few dozen to hundreds of photos, depending on the capacity of the card. Typically, cards come in a range of sizes from 512 megabytes (MB) up to many gigabytes (GB). The more memory you have available, the more photos you can shoot before having to download the pictures and erase the images on the card.

Memory Card Types

There are several different memory card formats available, but you'll need to purchase ones that are specifically designed for use with your camera. Some cameras provide dual slots that allow you to use more than one type of memory card (an option that seems of dubious value to me). Among the types of cards available are CompactFlash, Secure Digital (SD), Memory Stick, and xD. Keep in mind that these are different card types, not brands, and many companies manufacture each type of card. No particular format is better than any other in terms of picture quality or reliability.

What Size Memory Card Do You Need?

The amount of memory that you need depends on two important things: one, what size files your camera creates, and two, how many pictures you expect to take. It's always better to have more memory than less because, once you fill up your memory cards, you have to stop shooting. Imagine your dismay when you're shooting photos at the beach and a double rainbow soars across the sky right after you've used up your last memory card. Since taking digital pictures is essentially free, you will probably shoot many more photos than you think you will.

The table below shows the approximate number of image files you can save to a memory card when shooting in JPEG mode. As you can see, you can save quite a number of files to today's high-capacity cards. One thing to keep in mind is that while shooting to one large card is convenient, you run the risk of losing lots of images if you misplace or damage it.

Memory Card Capacity Chart *						
Megapixels	File Size (MB)	1 GB	2GB	4GB	8GB	16GB
6	1.7	550	1100	2200	4400	8900
7	2.0	450	900	1800	3600	7300
8	2.3	400	800	1650	3300	6650
10	2.9	225	650	1300	2600	5200
12	3.4	275	550	1100	2200	4400

* Card capacity and file size are approximate; numbers will vary among camera models

14 3.98

Note:

Memory cards are exceptionally durable and can take considerable abuse. It's important, however, to not get the cards wet or let dust get inside them. Store them in a card wallet or plastic case when not in use.

1.6 File Formats

An important decision that you'll encounter in digital photography is choosing a file format for recording your images. A file format is nothing more than the particular method that you tell the camera to use to store digital information. The most common file formats are JPEG (.jpg) and RAW (.raw, or a manufacturer-specific extension like .crw for Canon), and though much heated debate takes place among photographers about which is best, for most of us the JPEG format is made to order. When you want to take your photography a step further and spend time really working on images in the computer, you may want to try RAW. But if you are just getting into photography, stick with JPEGs—they are simpler to deal with and are certainly capable of great results. If shooting with a point-and-shoot camera, there may be no need to worry about this issue since most of these models only offer JPEG capture.

1.7 Image Quality

Image quality, or compression, can have a large effect on your picture's appearance. It's almost always best to shoot with your camera's Highest Quality setting.

In addition to file format, many cameras also allow you to adjust what is called "image quality." When you shoot JPEGs, your digital camera uses a compression scheme to shrink the images so that they are easier and faster for the camera to manage, and so that more can fit onto your memory card. There is a catch, however: The amount of compression affects image quality. In general, it's best to use the least amount of compression (the highest quality setting) that your camera offers if you intend to print your images. Lower quality settings (higher rates of compression) will let you squeeze more images onto your memory card, but it will cost you picture quality. These days, memory cards are fairly inexpensive, so it's better to always shoot at the highest quality setting and fill up more cards. While some image quality is always lost during JPEG compression, as long as you use the least amount of compression possible in-camera, you will never notice a decline in quality.

Exposure mode: Aperture Priority
Focal length: 70mm
Aperture: f/11
Shutter speed: 1/30
White balance: Cloudy
ISO: 200

Note:

JPEG Compression—A Cautionary Note

The most common type of compression is used with JPEG images (short for Joint Photographic Experts Group, if you're a trivia buff). Your computer is able to read compressed images and return them to their larger size. However, bear in mind that JPEG is a "lossy" format. In other words, each consecutive time that you save a JPEG image, some minimal amount of information will be lost. To avoid this, save the file as a TIFF (which is not a "lossy" format) once you download it to your computer if you plan to work on it a lot.

2

Learning About Lenses

Since the lens is the eye through which your camera sees the world, you should have some knowledge of just how lenses work and how they differ from one another. With the exception of D-SLR cameras—which allow for interchangeable lenses—almost all digital cameras come with a built-in zoom lens that lets you adjust focal length at the push of a button or the twist of a lens barrel. Changes in focal length can have a profound effect on the look of your images.

2.1 Finding the Right Perspective
with Focal Length

The boxes superimposed on this image show how different focal lengths can affect the angle of view your camera sees. The red box represents a wide-angle view (say, from a 28mm lens), while the blue box represents the view from a normal lens (around 50mm). The yellow box shows a telephoto angle of view (from a 100mm lens, perhaps).

Focal length is measured in millimeters and describes the "angle of view" of a particular lens. The bigger the number is, the "longer" the lens is said to be, and the more narrow its angle of view. The smaller the number is, the "shorter" the lens is said to be, and the wider its angle of view. Longer focal lengths also magnify distant objects more than shorter focal lengths do. If you double a lens' focal length from 100mm to 200mm, for example, you will double the size of your subject in the viewfinder. Shorter focal lengths take in a wider view of the world and make subjects seem farther away. Many zoom cameras will display the focal length you're using for your shot in the viewfinder or on the LCD screen.

Note:

Do you know what the millimeter measurement on a lens actually represents? In simple terms, it's a measurement of the length from the imaging plane in the camera (the sensor) to the outer lens element (or the front of the lens). That's why a 24mm lens is physically much shorter than a 300mm lens!

2.2 Focal Length Magnification

The small sensors in many digital cameras make subjects appear closer than if they were seen through a 35mm camera with the same focal length lens.

Because most camera sensors are smaller than a frame of 35mm film, lenses designed for 35mm film cameras have a focal length that is effectively longer when used on a digital camera. This is because the sensor is only seeing part of the image that the lens is creating. Imagine a picture on a 35mm film strip. Now imagine a small rectangle drawn inside of it. If you were to take only the portion of the image in the smaller rectangle and enlarge it slightly to be the same size as the film strip, the image from the smaller rectangle would look "zoomed in." (If this sounds confusing, don't worry about it! Just rely on your LCD monitor, where what you see is what you get.)

The difference between the focal length of a lens on a 35mm camera and that same lens placed on a digital camera is called the focal length magnification factor. If you have a digital compact or advanced digital zoom camera that does not take interchangeable lenses, it is not likely that you will need to use this information. If you have a D-SLR, however, knowing your camera's focal length

Exposure mode: Auto
Focal length: 300mm
Aperture: f/5
Shutter speed: 1/1600
White balance: Sunny
ISO: 200

did u know?

Thanks to smaller image areas compared to 35mm film, telephoto lenses become even more capable of capturing distant subjects when used on a digital camera, as seen in this detail picture of the Notre Dame cathedral in Paris.

magnification factor will help you to calculate the actual focal length of a given lens when used with your camera's digital sensor. If a D-SLR camera has a 1.5x magnification factor, for example, a 100mm lens has an effective focal length of 150mm when used on that camera body.

The benefit of the focal length magnification factor is that your lenses automatically become longer (without any loss in aperture speed)—which is great for wildlife and sports photographers. If you own a moderately long 300mm telephoto lens, for example, it would become a whopping 450mm lens on a D-SLR with a 1.5x magnification factor. Imagine sitting in the cheap seats at Fenway Park and getting great action shots of center field! The downside is that the wide-angle lenses are no longer quite so wide. An excitingly wide 24mm super wide-angle lens, for instance, becomes a rather mundane 36mm lens. Most lens manufacturers offer wide-angle lenses specifically for use with D-SLR cameras.

The 35mm Equivalent

One phrase you'll hear over and over again in discussions of lenses for digital cameras is "35mm equivalent." Actual focal lengths for lenses on digital cameras are different than those on 35mm cameras because the size of the digital sensor is typically smaller than a 35mm frame of film. However, since most of us are more familiar with 35mm lens focal lengths, manufacturers often describe lenses on digital cameras in terms of what the equivalent focal length would be if that same lens were used on a 35mm camera. This allows people to have some method of comparison—a reference point. In the following discussions, we'll use the 35mm equivalent focal lengths just to keep things simple.

2.3 Choosing a Focal Length

• Normal •Wide-Angle •Telephoto

Focal lengths are of key importance to creative photography. Imagine if there was only one fixed focal length for all cameras, and the only way you could get a different angle of view was to walk up to or away from your subject. Sounds like a lot of work, right? But then imagine you want to take a detail picture across the Grand Canyon. How would you get there? Being able to use lenses with varying focal lengths allows us to see our subjects from different angles of view and in creative ways.

Normal: Focal lengths that are between roughly 40mm and 58mm are called "normal" because the angle of view approximates what our own eyes see. When you take a picture at a normal focal length, distances and sizes appear very natural and "correct."

did u know?
For D-SLR cameras, there are many lenses available to cover any range of focal lengths.

© Olympus

did u know?

"Normal" focal lengths capture a scene similar to the way our eyes would perceive it.

Wide-angle: As you've probably guessed, wide-angle focal lengths are wider, or "shorter," than normal focal lengths. Because they have a wider angle of view, they make subjects seem farther away and smaller in size. You can exploit this quality to stretch and exaggerate subjects and the spaces between them. If you were to photograph a fishing pier at a wide-angle focal length, for example, you could make it appear to be considerably longer than it really is. Most digital cameras have a maximum wide-angle setting of about 28mm in 35mm equivalent. (The actual lens may be 18mm or less at its widest angle, but this number must be multiplied by the focal length multiplication factor to arrive at the 35mm equivalent of 28mm).

Telephoto: Telephoto focal lengths are those that are longer than the high end of the normal range (which is about 58mm). As focal lengths get longer, spaces and distance are compressed—and the longer the focal length

Exposure mode: Aperture Priority
Focal length: 28mm
Aperture: f/8
Shutter speed: 1/125
White balance: Auto
ISO: 200

did u know?
Choose wide angle lenses to capture a whole subject, and even its surroundings, in your picture.

did u know?
Using adapters for your lenses can add variety to your photography by offering different angles of view.

of the lens, the more apparent the compression becomes. You've probably seen sports shots where the football players appear to be almost stacked on top of one another. That effect is caused by the photographer using a very long telephoto lens to take close shots of the subjects (while avoiding being tackled). Keep in mind, however, that even though telephoto focal lengths are great for bringing distant subjects—like wild animals and shy kids—up close and personal, the downside is that camera shake is also magnified. When shooting with focal lengths longer than 200mm, it's important to find a way to steady the camera. A tripod is the ideal tool for holding a camera steady, but a fence rail or a car hood will also work.

Adapters

Even though you can't remove or switch lenses on a compact or advanced digital zoom camera, you can broaden the focal length range with the use of auxiliary lenses. Most camera manufacturers make wide-angle and telephoto adapters that simply screw on to the front of your lens. Or, if you want additional close-up capability, there are also accessory close-up lenses available for many cameras.

Left: A wide-angle lens will give you a very broad view of a scene. Below: A telephoto lens offers a much narrower and magnified view of the same subject.

2.4 The Zoom Lens Advantage

The benefit of having a zoom lens is that you have a whole range of different focal lengths built into your camera. Most compact digital cameras have a somewhat modest zoom range of about 3x, which means that the longest focal length is three times greater than the shortest. A typical 3x zoom has a focal length range of 35-105mm, for example. Advanced compact digital zoom cameras may have zoom capabilities of up to 10x (38-380mm), or even 12x (38-456mm).

The creative advantage of having a zoom lens is that you can stand in one spot and alter your composition simply by changing focal lengths. But don't let the convenience of zooming keep you from using an even better creative accessory—a good pair of sneakers for walking closer to your subject.

Optical vs. Digital Zoom

Digital cameras often advertise two different types of zoom: optical zoom and digital zoom. The only zoom you need to pay attention to is optical zoom, which describes the actual zoom range of the camera lens. Digital zoom is nothing more than in-camera digital cropping. If your digital zoom is turned on, the lens will extend as far as it can, and then the camera will begin zooming in on the image digitally, which lowers the image quality. If you really want to zoom in on your subject farther than your lens will allow, you can crop the image later using image-processing software in your computer and do a better job than what the digital zoom feature offers.

did u know?
Use your zoom lens when shooting subjects that might be startled if you get too close.

Exposure mode: Auto
Focal length: 220mm
Aperture: f/5
Shutter speed: 1/320
White balance: Cloudy
ISO: 640

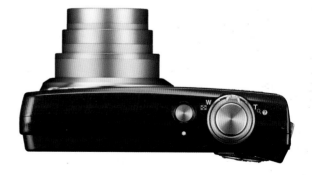

2.5 Fast Lenses

Mean More Exposure Options

Another way that lenses are defined is by their "lens speed," which refers to the largest aperture of a particular lens. If your lens has a maximum aperture of f/4, for example, then f/4 is the speed of that lens (see page 50 for more on aperture). Lenses that have large maximum apertures are described as "fast lenses" and are usually more desirable (and more expensive) because they let more light into the camera. Why are they called "fast," though? Well, since the larger aperture can let more light into the camera, fast shutter speeds can still be used to get a decent exposure, even in low light conditions. Because they allow more light in, fast lenses are particularly useful with low-light subjects.

Exposure mode: Aperture Priority
Focal length: 60mm
Aperture: f/3.5
Shutter speed: 1/200
White balance: Auto
ISO: 250

did u know?

A "fast lens," or one with a large aperture like f/3.5, can help you get sharp exposures in low-light conditions by allowing for faster shutter speeds. This is especially important if hand holding the camera, when long shutter speeds would create blurry photos. In this image, the large aperture also helped create the out of focus background.

Photo © Kevin Kopp

Note:

How can you know what aperture (or apertures, if it's variable speed) your lens is? All lenses have markings on their front, near the glass, that specify their maximum apertures. If using a point-and-shoot camera or the zoom kit lens that came with your D-SLR, you'll most likely find your lens is variable aperture.

Lens speed gets a bit more complicated with zoom lenses because they often have what is called a "variable speed" aperture. What this means is that the maximum aperture of a zoom lens gets smaller as the focal length gets longer. So, for example, you might have a 35-150mm zoom with a maximum aperture of f/4-5.6. While the maximum aperture at 35mm is f/4, by the time you zoom the lens to 150mm, the maximum aperture "slows down" to f/5.6.

2.6 Small is Beautiful

with Macro Photography

Few subjects are more interesting to photograph than close-ups of things like flowers and insects. In fact, one of the more fascinating aspects of digital photography is that even very simple digital cameras possess a tremendous close-focusing capability. You can often get to within inches of tiny subjects to make terrific close-up photographs.

You'll find that most digital cameras have a setting just for macro photography, and it's usually designated with a flower icon on the mode dial or in the camera's menus. This setting takes the guesswork out of macro photography for you by telling the camera you are shooting a close-up.

Exposure mode: Auto
Focal length: 155mm
Aperture: f/5.6
Shutter speed: 1/13
White balance: Auto
ISO: 200

Exposure mode:
Aperture Priority
Focal length: 242mm
Aperture: f/4.2
Shutter speed: 1/110
White balance: Auto
ISO: 100

2.7 Caring For Your Lens

The front surface of your lens is one of the most vulnerable parts of your camera. Not only is it made of glass and usually unprotected when you're shooting, but it's also the first thing to bump into a doorknob or get ice cream dropped onto it when you're out shooting. It's a good idea to cover or retract the lens when you're not actually taking a picture. It's also a good idea to periodically clean your lens. Use canned air to blow off loose dust, then use a microfiber cloth or lens tissue to very gently wipe the surface of the lens.

If you own a D-SLR, you'll want to make sure you always cover the lens with the lens cap when not using the camera, especially when storing it. And last but not least, it's a good idea to store lenses that aren't being used in a camera bag or lens case so they don't get knocked around. Lenses are expensive—you don't want to replace one just because your dog thought your new lens looked like a fun toy to roll around the house.

© Sony

Tip

If you're serious about protecting your lenses and keeping them clean, consider making a camera care kit. All of the following items can be found around the house or at a camera retailer.

2 microfiber cloths: Choose different colors; one for cleaning your lens and another for cleaning the LCD.

1 bottle of photographic lens cleaner: Apply a drop of solution to the microfiber cloth, not the lens itself. Wipe any residual cleaner from the lens with a dry part of the cloth.

1 cotton cloth: To dry the camera and lens when caught in wet conditions.

Exposure mode: Auto
Focal length: 57mm
Aperture: f/9
Shutter speed: 1/250
White balance: Auto
ISO: 200

Exposure

t's important that your camera captures just the right amount of light. If too much light strikes the sensor, your picture will be overexposed and look washed out. If too little light hits the sensor, your picture will be underexposed, appearing muddy and dark, and highlights will be gray instead of white. Fortunately, the automatic exposure system in most cameras is very accurate and very reliable. So, in most situations, all you have to do to get a good exposure is set the camera to one of several autoexposure modes and your exposures will be perfect. There might be times, though, when for either technical or creative reasons, you want to override the exposure settings chosen by your camera. In the following pages we'll look at how light is measured and which camera features control how exposure is set.

3.1 Controlling Motion

with Shutter Speed

Despite all the electronic wizardry that makes up your camera, there are really only two camera settings that control the amount of light getting in: shutter speed and lens aperture. If you understand what each of these controls does and how they relate to one another, you will have a huge creative weapon at your command. Let's first review how controlling the shutter can benefit your photos. Note: Many point-and-shoot cameras don't have user-definable shutter speeds and apertures.

Shutter speed controls how long the camera's shutter remains open and, in turn, how long light is allowed to enter the camera. The longer you leave the shutter open, the more light enters the camera. Most digital cameras have a shutter speed range that goes from 30 seconds to as fast as 1/8000 second. Your manual will tell you exactly which speeds you have available.

Look at the chart of standard shutter speed choices below and you'll see a pattern: As you progress through the speed settings, each faster speed is twice as fast as the one before it. Similarly, each slower shutter speed, if you move backwards through the chart, is twice as long as shutter speed setting ahead of it. (The exception here is the stop between 1/60 second and 1/125 second, in which the speed is not exactly doubled or halved.) Each change in shutter speed is called a stop. (Changes in aperture are also called stops—see page 50.)

Standard Shutter Speeds

| 1/15 | 1/30 | 1/60 | 1/125 | 1/250 | 1/500 | 1/1000 | 1/2000 | 1/4000 |

Exposure mode: Shutter Priority
Focal length: 57mm
Aperture: f/5
Shutter speed: 1/500
White balance: Cloudy
ISO: 200

Freeze! By using a fast shutter speed of 1/500, all of the action in this photo was caught in sharp detail, as if time had suddenly stopped.

Each time you go to the next faster speed, you halve the amount of time that light is allowed into the camera. Each time you go to a slower shutter speed, you double the time. The shutter speeds shown in the chart here represent the traditional shutter speed sequence, but many digital cameras use intermediate shutter speeds that fall between the traditional numbers, such as 1/750, for example.

As you might have guessed, being able to adjust shutter speeds also has a creative application because the duration of the expo-

sure time greatly affects the appearance of moving subjects. Long shutter speeds cause moving subjects to blur, while fast shutter speeds stop motion. The actual degree of subject blur or sharpness depends on several factors in addition to shutter speed, including how fast the subject was moving and your shooting position relative to the subject. The key thing to remember is that if you want a moving subject to blur, use a longer shutter speed; if you want to freeze the action, use a faster shutter speed.

Another advantage of using long shutter speeds is that you can keep the shutter open long enough (depending on your particular camera's capabilities) to record dark subjects or subjects at night.

3.2 Using f/stops

to Your Advantage

Aperture Settings

Though you're not likely to notice it unless you look directly into the lens as you take a picture (of yourself, presumably), there is a small iris-shaped diaphragm in the middle of your lens that opens and closes at the instant you take a picture. This diaphragm is known as the lens aperture and it controls the amount of light that reaches your camera's sensor. The larger the opening, the more light that enters the camera; the smaller the opening, the less light that comes through. Just think of a hole in the bottom of a bucket—a small hole drips, a big one gushes.

Like shutter speeds, aperture settings are also defined by a series of numbers—in this case, they are called f/numbers (or in photo slang, f/stops). But here's the tricky bit with regard to f/stop numbering: The larger the f/number is, the smaller the opening in the lens. The smaller the f/number is, the larger the opening in the lens. A lens opening of f/16, for example, is relatively tiny when compared to an aperture of f/4.

If you have trouble remembering which apertures let in more light and which let in less, think of them as fractions: If one of your friends offers you 1/4 of a pie, they're giving you a lot more than if they only offer you 1/16 (in which case you would want new friends anyway). Of course, if fractions scare or confuse you, just ignore that analogy completely and remember the facts:

High f/numbers = smaller lens openings

Low f/numbers = larger lens openings

Exposure mode: Aperture Priority
Focal length: 157mm
Aperture: f/11
Shutter speed: 1/640
White balance: Sunny
ISO: 200

did u know?

Learning how aperture choices affect your images is key. On th bright, sunny day in the deser small aperture (in conjunction a fast shutter speed) was need get a correct exposure that wa overly bright.

Exposure mode: Shutter Priority
Focal length: 60mm
Aperture: f/4.5
Shutter speed: 1/1250
White balance: Custom
ISO: 800

did u know?

A dark setting is the perfect candidate for using a large aperture to let in more light. This is when it's nice to have fast lenses with wide maximum apertures at your disposal.

The chart below shows the typical progression of f/stops. The stops shown represent the traditional lens aperture sequence, but many digital cameras also use intermediate aperture settings that fall between the traditional numbers.

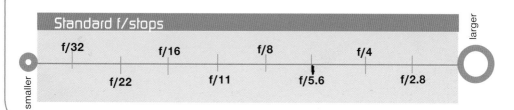

Standard f/stops

smaller — f/32 — f/22 — f/16 — f/11 — f/8 — f/5.6 — f/4 — f/2.8 — larger

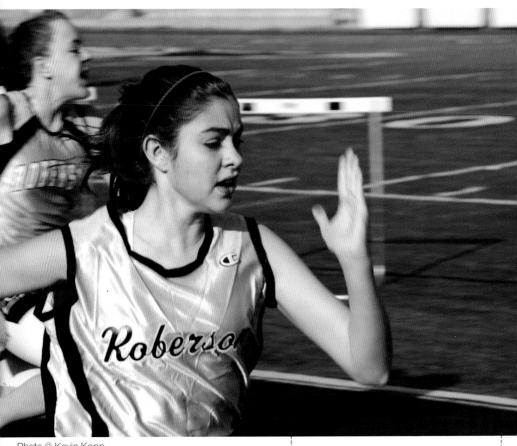

Photo © Kevin Kopp

Exposure mode: Shutter Priority
Focal length: 68mm
Aperture: f/8
Shutter speed: 1/250
White balance: Sunny
ISO: 100

did u know?

Reciprocal relationships between aperture and shutter speed become important when you want to achieve a creative goal and still get a good exposure. Here, a fast shutter speed helped stop most of the action while a medium-wide aperture was needed to let in more light during the short exposure.

Note:

Aperture numbers share the exact same mathematical relationship as shutter speeds do. As you move to the next larger lens opening (from f/5.6 to f/4, for example, which is moving one stop up) you double the amount of light entering the camera. Similarly, as you move to the next smaller f/stop (f/11 to f/16, for instance, which is moving one stop down) you cut the amount of light in half.

A Perfect Reciprocal Relationship

There is a perfect reciprocal relationship between f/stops and shutter speeds. In other words, if you cut the light in half by stopping down to the next smallest f/stop, you can still get the exact same exposure if you then adjust the shutter speed to the next slowest setting. What this means is that there is not just one combination of shutter speed and aperture that will yield a correct exposure, but an entire series of them. The chart below demonstrates this point. There are ten different exposure combinations that will all create the exact same exposure in terms of brightness. In other words, double both the shutter speed and the amount of light for one shot, then halve the shutter speed and the amount of light for the next shot, and both exposures will be equal.

So why is one shutter speed and aperture combination better than another? Knowing that you can get the exact same amount of light into the camera with various aperture and shutter speed combinations opens up a wide variety of creative options. Think back to what we said about shutter speed and motion, for example. Imagine that you're photographing a track event and you want to stop the runner in motion. By selecting a shutter speed and aperture pairing that favors a fast shutter speed, you can stop the action. Read on to find out why favoring a combination with a larger or smaller aperture may be best.

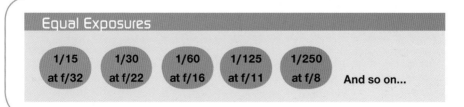

Equal Exposures

| 1/15 at f/32 | 1/30 at f/22 | 1/60 at f/16 | 1/125 at f/11 | 1/250 at f/8 | And so on... |

3.3 Controlling the Focus

With Depth of Field

While this chapter is about exposure, depth of field is a subject related to aperture settings, so this is a good place to discuss it. Whenever you focus a camera, you focus on a subject at a specific distance from the lens. However, focus isn't like the edge of the earth in pre-Columbus days—it doesn't just suddenly drop off. In any given scene, there are areas in front of and behind your subject that will also appear to be in relatively sharp focus. Depth of field is the range from near to far in a photograph that appears to be in sharp focus, and it's a supremely important photographic concept.

Although there are other factors at work, the primary factor in determining how much depth of field a particular photo will have is the size of the aperture in use. Smaller apertures produce more depth of field and larger apertures produce less. A landscape shot at f/22 will have considerably more near-to-far sharpness than the same scene shot at f/5.6, for example. The focal length of the lens you're using and your distance from the subject also influence depth of field, but all other things being equal, aperture size will determine how much of a scene will be in sharp focus.

Photo © Kevin Kopp

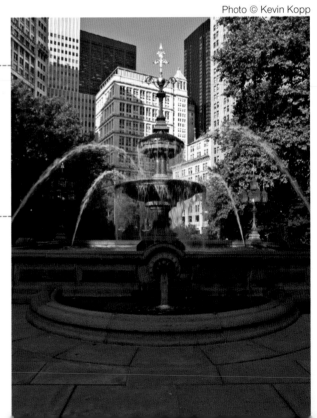

Exposure mode: Manual
Focal Length: 28mm
Aperture: f/11
Shutter Speed: 1/30
White Balance: Shade
ISO:100

did u know?
Because this image is in focus from the foreground subject far into the background, it can be said to have large depth of field.

Exposure mode:
Aperture Priority
Focal length: 270mm
Aperture: f/5
Shutter speed: 1/60
White balance: Cloudy
ISO: 200

did u know?

Creating shallow depth of field means shooting a picture where the background behind the subject is out of focus. In this image, a telephoto lens and wide aperture were used to create the effect.

Manipulating Depth of Field

Depth of field is an important concept in all types of photography because it's one of the primary ways for you to put emphasis on important subject elements. In a portrait, for example, you may want to limit depth of field so that only the face of your subject is in sharp focus. In a landscape, on the other hand, you may want focus to extend from nearby elements (a tree in the foreground, for instance) to the horizon. Knowing what factors influence depth of field is very important. The following are the key elements that affect depth of field:

f/stop: The smaller the aperture, the greater the depth of field. To limit depth of field, choose a wide aperture (f/4 instead of f/16, for example. f/16 would give you large depth of field).

Camera-to-subject distance: The closer you get to any subject, the less depth of field you have (with any given lens and aperture combination). If you want more depth of field, back away from the subject. If you want less, move closer.

Lens focal length: The shorter the focal length of the lens, the more depth of field you will get at any given camera-to-subject distance at any given f/stop. Therefore, a telephoto lens is better for creating shallow depth of field, if that's your creative intent.

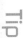

Tip

3.4 Adjusting to the Light
(or Dark) with ISO

The ISO setting on your camera controls the sensor's relative sensitivity to light. The higher the ISO number, the more sensitive you are instructing the sensor to be. You should select an ISO based on how much light you have available in a given scene. If it is a bright sunny day, you might choose an ISO of 100 or 200, for example. On a cloudy day, or in the shade, an ISO of 400 might be better. In low-light situations (such as an indoor sporting event, for instance) you may want to raise the number to a higher ISO setting, such as 800 or 1600. The great part about shooting digitally is that you can change the ISO at the push of a button without having to switch to another roll of film to get the effect that you want. Try shooting the same scene at several different ISOs and review the results to see what works best. You can always delete the shots that don't work.

Exposure mode: Manual
Focal length: 78mm
Aperture: f/13
Shutter speed: 28.0
White balance: Cloudy
ISO: 200

did u know?

Normally, when shooting snapshots in lowlight conditions like this scene, you'd want to choose a high ISO like 800 or 1600 to make the sensor more sensitive to light. However, since this shot had a very long exposure of 28 seconds, the ISO was kept low (at 200) so the image wouldn't become overexposed.

Noise

Higher ISO settings enable you to capture images in dim light, but they also create an inherent flaw called "noise." Noise appears as tiny dots of light or color that do not belong in the image. Again, experiment with the different ISO options available to you and see how low an ISO you can get away with and still capture a low-light image.

did u know?

Raising your ISO too high can result in noisy images.

3.5 Choosing Exposure Modes

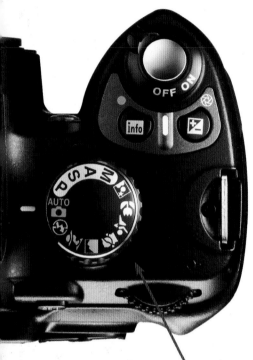

The exposure mode dial

particular scene. So, to help you interpret different subjects in just the right way, virtually every digital camera offers a variety of auto-exposure options, or "modes."

These modes are generally found on a dial on the top of the camera, making it easy to switch back and forth between them depending on your subject matter. If your camera is a D-SLR, a compact zoom, or an advanced point-and-shoot, it will usually offer modes for Aperture Priority mode, Shutter Priority mode, Program mode, and Manual mode (as well as a full Auto mode, of course). We'll look at these options in detail on the following pages.

Technology is great, but getting a good exposure involves more than just recording a scene's tonalities correctly. There are creative (i.e., human) decisions to be made too: Are you shooting a landscape that requires an extensive amount of depth of field (see page 54)? Or are you shooting sports where you want to stop (or exaggerate) the action? Since telepathy has not been developed as a camera option yet, the camera has no way to know what you want to emphasize in a

Program Mode and Auto Mode

Virtually all cameras have a fully automatic exposure mode. In other words, the camera will automatically select an aperture and shutter speed combination based on the information gathered by the light meter. On some cameras this mode will be called Auto and on others it is referred to as Program—there are even some cameras that have both! The difference between Program and Auto is that, on some cameras, the Program mode allows you to "program shift," an option that lets you

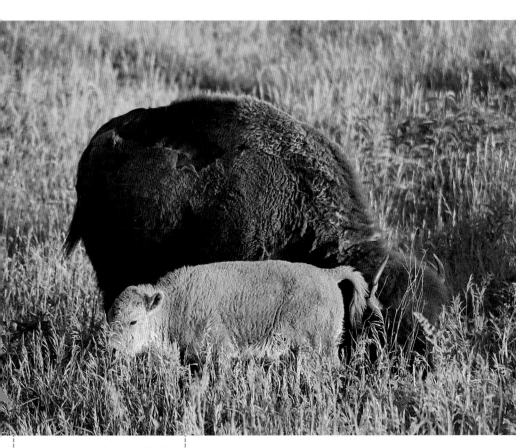

Exposure mode: Aperture Priority
Focal length: 300mm
Aperture: f/5.6
Shutter speed: 1/160
White balance: Cloudy
ISO: 200

did u know?

Selecting the Aperture Priority expo-
sure mode enables you to dictate
the amount of depth of field. Here
a relatively wide aperture of f/5.6
was used to restrict focus to just the
bison and throw the prairie around
them into softer focus.

change the aperture or shutter speed while
still maintaining the same exposure value. (See
the chart on page 53 for examples of different
aperture and shutter speed combinations that
the produce the same exposure value.) In Auto
mode you can only use the combination that
the camera has selected for you. Check your
camera manual to see what options are avail-
able with your equipment.

Aperture Priority

When depth of field is an important consideration, this mode (usually indicated by "A" or "Av" on the mode dial) lets you select the appropriate aperture, and the camera selects the correct corresponding shutter speed. Since manipulating the range of sharp focus is such an integral part of my work, this is the mode that I choose most often. In fact, I would say that 80% of my photos are shot using Aperture Priority.

Shutter Priority

In this exposure mode (usually indicated by "S" or Tv" on the mode dial), you select the shutter speed and the camera assigns the corresponding aperture. This is the mode to choose when stopping or exaggerating action is your prime consideration. As mentioned earlier, by selecting a fast shutter speed, you can freeze subject motion; by selecting a slower shutter speed, you can let the subject dissolve into a creative blur.

Manual Exposure

If your camera offers manual exposure as an option, you may want to give it a try once you get more experienced in working with creative exposures. There will be times when—either for technical or creative reasons—you will want to override the camera's exposure recommendations. In Manual mode (usually indicated by an "M" on the mode dial), the camera's meter will display what it thinks is the correct exposure setting, but you must select your own aperture and shutter speed combination.

Exposure Limitations

When working using either Shutter Priority or Aperture Priority, in some extreme lighting situations you may choose an aperture or shutter speed for which the camera cannot select a correct corresponding setting. If you're trying to shoot on a very bright beach with a very wide aperture, for example, the camera may not be able to find an appropriately fast shutter speed. Or, if you're using a very long exposure time to blur a waterfall, for instance, the camera may not be able to find a sufficiently small aperture. The camera will warn you (usually with a blinking symbol) that you've gone beyond its capabilities for that scene, and you may get a poor exposure.

Exposure mode: Shutter Priority
Focal length: 142mm
Aperture: f/4
Shutter speed: 1/200
White balance: Auto
ISO: 200

did u know?
Use Shutter Priority mode and set a fast shutter speed when you want to capture moving subjects and keep them sharp (without the motion blur common from a longer shutter speed).

3.6 Get Better Results

Through Scene Modes

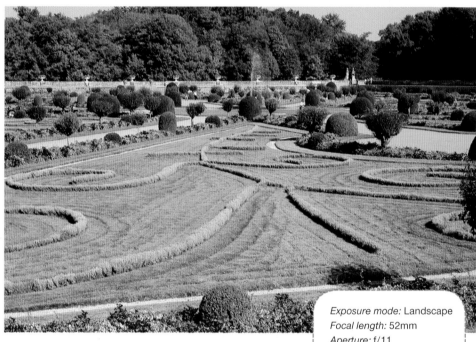

Exposure mode: Landscape
Focal length: 52mm
Aperture: f/11
Shutter speed: 1/200
White balance: Cloudy
ISO: 200

In addition to the exposure options described above, many digital cameras also provide a host of subject-specific exposure modes usually referred to as "scene" modes. These modes are designed to provide an automatic exposure that is biased for certain shooting situations. Engineers must have a great time thinking up potential shooting situations because some cameras boast dozens of options! Typically, each mode is indicated by an icon on the mode dial, but scene modes may also be found in the internal menu system as menu options. The following are some of the more common scene modes. Note that camera models differ and not all cameras will offer every mode discussed here.

Landscape: This is an excellent mode for landscape or scenic photography when you want to have lots of near-to-far sharpness. The camera gives priority to selecting a small aperture.

Portrait: Portraits often look best when the subject is sharp but the background is out of focus. In this mode, the camera selects a wide aperture to ensure shallow depth of field.

Sports/Action: When stopping the action is important, this mode lets you concentrate on following the action while the camera automatically selects the fastest available shutter speed.

Night Landscape: In this mode, the camera will choose a longer shutter speed than it would in daylight conditions. If you were shooting in New York's Times Square at night, for example, the longer exposure time would enable you to capture detail in dark areas, not just record the bright city lights. You'll probably need a camera support (such as a tripod) to keep the images sharp.

Night Portrait: If you're shooting portraits either indoors or outdoors at night, this mode will first fire a flash to illuminate your subject, then leave the shutter open to capture some background detail—a very useful mode if you remember to use it!

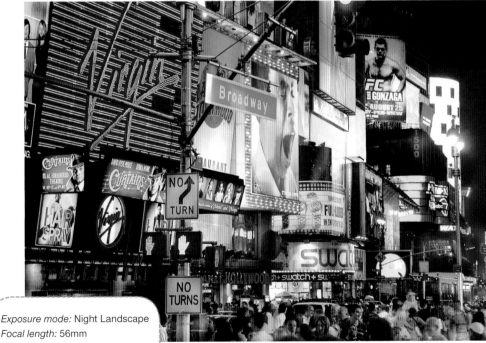

Exposure mode: Night Landscape
Focal length: 56mm
Aperture: f/4.5
Shutter speed: 1/20
White balance: Cloudy
ISO: 400

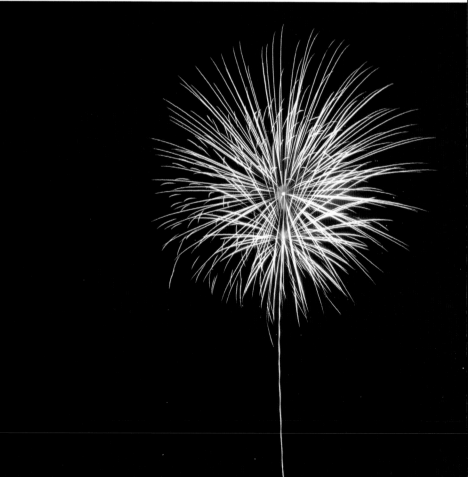

Exposure mode: Fireworks
Focal length: 40mm
Aperture: f/11
Shutter speed: 7.0
White balance: Auto
ISO: 100

Photo © Kevin Kopp

Close-Up: Most digital cameras— even tiny compacts—take exceptional close-up photos. This mode optimizes the exposure settings to provide just enough depth of field to keep tiny close-up subjects in sharp focus.

Fireworks: This exposure mode is intended to leave the shutter open long enough to capture one or more bursts of fireworks, but is also good for capturing city lights or streaks of taillights in traffic.

Panorama: It's possible with image-processing software to "stitch" together several images into one long panorama. In this mode, the camera helps you line up the segments necessary to create a seamless panoramic shot.

Face and Smile Detection: These modes represent fairly new technological innovation, and they can usually be found in point-and-shoots as well as D-SLRs. Face Detection mode scans the scene, searching for two eyes, a nose, and a mouth. When it notices faces in the scene, the camera will automatically adjust exposure and focus for a portrait. Some cameras can recognize 10 to 15 faces in a scene. Smile Detection mode takes this technology one step further and actually snaps a picture when it detects a laugh or grin from your subject.

3

3.7 Metering Light

For the Best Exposure

Exposure mode: Aperture Priority
Focal length: 70mm
Aperture: f/10
Shutter speed: 1/400
White balance: Sunny
ISO: 100
Exposure Compensation: +0.33

did u know?

Very bright shooting conditions, like sand on a sunny day, can be a challenge for your light meter. To avoid such images being captured as a middle shade of gray, use exposure compensation to add exposure and get a bright scene.

Exposure mode: Aperture Priority
Focal length: 250mm
Aperture: f/6.3
Shutter speed: 1/640
White balance: Auto
ISO: 640

Thanks to the hard work of some very brilliant engineers, your camera uses an extremely sophisticated and precise light meter to measure exactly how much light is reflecting from any given scene. The camera then takes that information and selects the correct combination of camera settings to make a good exposure. There are a number of different types of built-in light meters, and some cameras provide a variety of metering options. Read your camera's manual to find out which metering options are available for your camera.

Most D-SLRs, and some point-and-shoots, offer a few metering options:

Spot metering: Uses a small portion of the viewfinder's center to meter light.

Center-weighted averaging: Roughly 60%-80% of the viewfinder's center is used for metering light, with the rest of the frame's light being averaged in to the total.

Average or Evaluative: Light from the entire scene is averaged to produce the exposure.

Partial: Meters a wider area than spot metering (10-15% of the frame), and is useful not metering bright or dark areas on the edges of the frame.

did u know?

Average metering works best for most subjects and shooting scenarios because it measures light from the entire scene.

Exposure Compensation

While the light meter in your camera is designed to create a good exposure from subjects of average brightness, problems arise with very bright subjects, like snow or sandy beaches, or very dark subjects, like your black cat sitting on a dark blue car. Because your meter is trying to create an average exposure, it will turn both the snow and the black cat to a medium shade of gray. If your camera has an exposure compensation feature, you can correct this flaw; add exposure to the bright scene that your camera would tend to underexpose, or subtract exposure from the dark scene that your camera would tend to overexpose.

3.8 Exposure Lock:

An Easy Trick for Big Results

When you depress the shutter button halfway, most digital cameras lock exposure on whatever they see. This automatic appraisal of the scene by the camera works well most of the time, but not always. There will be times when you'll want to use this exposure locking feature to help in problematic lighting situations.

Exposure mode: Shutter Priority
Focal length: 280mm
Aperture: f/7.4
Shutter speed: 1/20
White balance: Auto
ISO: 100

Photo © M. Morgan

Exposure mode: Shutter Priority
Focal length: 82mm
Aperture: f/13
Shutter speed: 1/60
White balance: Flash
ISO: 200

did u know?

In order to capture the light and dark tones created by the late summer afternoon lighting, a spot meter reading was taken on the middle value of green grass and locked in while the photo was recomposed. If the meter reading was based largely on the shadow areas in the middle foreground of the image, detail in the brighter grassy area would have been lost.

For example, say you are shooting a sunset, but a large part of the scene has darkly silhouetted people. If you point the camera at the people—the obvious subject of the scene—the camera's light meter will try to give the best exposure for those subjects. However, this could result in the sunset losing a lot of its vibrant color from the light meter suggesting too much exposure. To fix this problem, recompose the scene so the camera sees more sky and press the shutter button halfway. The camera's light meter is now giving the best exposure for the colorful sky. While still holding the shutter button, reframe the image around the people and take the picture. You should now get more satisfying colors from the sunset. You may have to try this a couple of times, metering off of different areas of brightness in the sky before you get the best exposure.

3.9 Understanding the Histogram

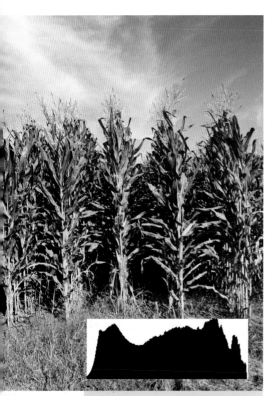

One of digital photography's greatest benefits is that you can review an image on the LCD screen immediately after you have taken it—something never before possible in the film days. This means you can check your exposure while still at the scene. Are your well-lit subjects bright, and shadow areas appropriately dark? Get used to checking your images to see if any adjustments need to be made. Also try enlarging images in the LCD to see if details exist in highlight and shadow areas.

This picture is properly exposed. Note how the histogram's peaks are in the middle of the graph (and not stacked up on the sides) and the downward slopes terminate before meeting the end of the graph. This means that no highlight or shadow details are lost.

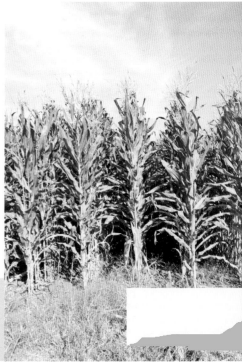

This photo is overexposed. Highlight detail is blown out—this shows in the histogram, which is clipped to the right. The gap in the graph on the left shows that the blacks aren't dark enough; they appear gray in the photo.

Photos © Kevin Kopp

While viewing the LCD screen can give you a good basic idea of a picture's exposure, there is a more accurate method: using the histogram, which is a graph of the exposure levels in your image. While the histogram sounds complicated and often intimidates many new photographers, it's actually quite easy to use. All you need to know is that the histogram is a representation of the light and dark areas recorded in your image. The left side of the graph represents the dark parts of the picture while the right side represents the bright parts. For a photograph of a subject with evenly distributed light and dark areas that is properly exposed, the histogram will look something like a hill, with its peak in the middle of the graph (meaning it's not too dark and not too bright). One thing to keep in mind is that a histogram's range of tones, or the "hill" in the graph, should slope down, and even terminate, before it gets to either end of the graph. When the histogram looks like a sharp cliff at the ends of the graph, it means an image is over- or underexposed and detail is being lost in the highlight or dark parts of the image. This loss of detail is called "clipping."

Of course, the histogram won't always look like a perfect hill if your subject matter is either very bright or very dark. There will often be times when you are shooting a scene like a ski slope that will obviously show the histogram being more heavily weighted to the right side of the graph. As long as details in the image's bright areas aren't being overly clipped, this histogram is okay because it represents a correct exposure for the bright scene.

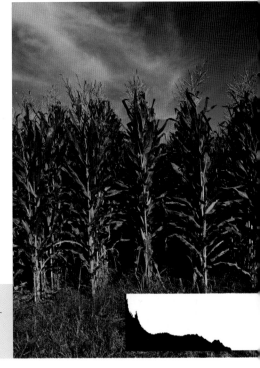

This photo is underexposed. Shadow detail is lost and the histogram is heavily weighted to the left, with obvious clipping of the dark areas occurring.

4

Understanding Light

T he most essential ingredient in any photograph is, of course, light. The light from the sun does more than merely illuminate the world, it also decorates, sculpts, and colors it with its ephemeral moods—some subtle, some outlandish. As the earth turns and the sun rises and sets, the appearance of everything around us evolves perpetually. Learn to see and anticipate the changes in daylight and you will begin to unlock the true essence of photography.

4

4.1 Getting Creative
with Light Direction

Exposure mode: Aperture Priority
Focal length: 116mm
Aperture: f/5.9
Shutter speed: 1/90
White balance: Auto
ISO: 100

did u know?

Front lighting can make colors and details come alive, especially if shot early in the morning or late in the day when the light is vibrant and warm.

As the earth spins around on its axis and the sun moves across the sky between dawn and dusk, the direction of the light hitting the earth changes. The way in which light strikes a subject relative to your camera position has a profound effect on both the subject's appearance and the mood of a photograph. Is the light falling on the front of the subject? Is it striking it from behind? From the side? Each lighting direction has its own unique qualities, advantages, and disadvantages, and once you become aware of them, you will be able to anticipate how changes in light direction will affect the look of outdoor subjects.

Front Lighting: Like a spotlight illuminating a Broadway stage, light that comes from the front has a bold and brassy feel to it. It can be very useful for igniting colors and revealing surface details. Subjects are front-lit when the sun is coming over your shoulder (as the photographer) and landing flatly on your subject. While it provides a lot of light and is easy to expose for, subjects shot using front lighting often lack texture or a sense of depth.

golden hour

Top Lighting: Photographically, at least, the midday sun is probably the least attractive type of daylight. When the sun is high overhead, textures and subtlety disappear, people get shadows in their eye sockets and under their noses, and landscapes lose their sense of depth. But there is also a good side to top lighting; colors are very bold and bright, and it's usually easy to expose for top-lit scenes. Most professionals, however, use the midday hours to scout pictures and then return at a more "attractive" time.

Side Lighting: One of the prettiest times of day occurs when the sun is low and pale yellow light rakes side-to-side across the landscape. Side lighting happens twice a day—early in the morning and late in the afternoon—so you have two shots at finding it. Textures are at their best in side-lit scenes because the light is illuminating every little bump and dimple, and casting myriad tiny shadows. Exposure is a little trickier because of the added contrast. If your camera has an exposure compensation feature, try adding an extra stop of light (using the "+" button) to open up dark shadows just a bit.

did u know?

Side lighting emphasizes detailed textures in a scene and usually provides colorful light. However, you may want to use exposure compensation to add a stop of light to brighten dark shadow areas.

Exposure mode: Aperture Priority
Focal length: 450mm
Aperture: f/5.6
Shutter speed: 1/160
White balance: Cloudy
ISO: 200

Exposure mode: Aperture Priority
Focal length: 168mm
Aperture: f/14
Shutter speed: 1/40
White balance: Cloudy
ISO: 200

did u know?

Backlighting often creates strong silhouettes when shot late or early in the day.

Backlighting: Backlighting occurs when your subject is between you and the sun. Landscapes are particularly interesting when backlit because the long shadows advancing toward the camera enhance both depth and texture. The tough part of shooting into the light, however, is that the scene can be contrasty and difficult to expose for. Again, if your camera has an exposure compensation feature, adding a stop of light will keep scenes from being underexposed.

Edge Lighting: Edge lighting occurs when backlighting is particularly brilliant, giving thin, "translucent" subjects (leaves, fields of tall grass, your daughter's bouncing ponytail) a soft glow, and giving more opaque subjects (tree branches in winter, a person in silhouette) a gilded edge of illumination that is often quite dramatic.

4.2 Shooting the Right Light

Exposure mode: Aperture Priority
Focal length: 450mm
Aperture: f/5.6
Shutter speed: 1/160
White balance: Cloudy
ISO: 200

did u know?

Dramatic lighting and intense sunsets are always waiting in the wings at the end of the day, especially during departing storms. Scout locations with simple but strong foregrounds an hour or so before sunset (or sunrise if you're an early riser) and wait for the show to begin.

If you want to learn how evocative light can be in transforming the appearance of a scene, just sit in a park some afternoon and watch as the daylight changes in its intensity and direction. From the unforgiving blast of overhead midday sun to the delicate wafts of buttery evening light, the slightest changes in the position of the sun radically alter the appearance of the natural world.

Scenes that appear humdrum and ordinary at noon can be mysterious and captivating as the sun drapes them in long yellow rays of morning or evening light. And few moments of the day are as beautiful as the brief slice of time when the sun is illuminating the morning sky with its rosy glow but hasn't yet cleared the horizon. Keep in mind, though, that the appearance of daylight changes faster at the beginning and end of the day, so you have to be ready to shoot when you see light that you like.

The Golden Hours

Photographers often refer to the first hour or so after sunrise and the hour or so before sunset as the golden hours because the sun at that time of day is very warm and, well, golden. Light is often softer and gentler during these hours also, which gives scenes a pleasing, romantic look. If you like Maxfield Parrish's illustrations, you'll love shooting during the golden hours. And if you really like backlighting but don't know what Parrish's work looks like, go look him up—you'll enjoy his vision and learn a lot about the beauty of natural light.

4.3 Assessing Light Quality

In addition to changes in direction and color, light also changes in its intensity throughout the day and as the weather changes. If you've ever sat on a beach under midday sun without a hat or an umbrella, for instance, you know just how harsh the light can be: Shadows are black, bright areas are obliterated, and there is little gradation between those two extremes. In bright sunlight, shapes are hard and edges appear sharp to the touch. The same beach on a mildly overcast day has an entirely different quality: Shadows are open and full of detail, tonal gradations are very gentle, and shapes seem soft and sensuous.

Soft Lighting: Early or late in the day, or when the sky is slightly overcast, the light is softer and is very flattering to both landscapes and portraits. The softer the light is, the more even the tones will be in a scene, eliminating problems with both contrast and exposure. Because shadows are more open and highlights are less extreme, you will have a much higher rate of good exposures when the lighting is soft.

Also, while a cloudy sky may not be your favorite thing to see when you're off on a photographic outing, the diffused light of a cloudy day creates a very pretty palette of

muted pastel tones. Take a picture of a local park sometime in both hard and soft light and you'll get a good sense of just how much the quality of light can alter your perceptions of a scene.

Hard Lighting: The brilliant light of a cloudless day can be harsh and unforgiving, but it is not altogether useless. Hard lighting can give colors a vibrant zest, and the deep shadows it creates can help to add texture and a three-dimensional feel to landscapes. But beware, the same extreme contrast range that makes it difficult not to squint, or to see without shading your eyes, can also make it tough to get a good exposure. Often the contrast range on brilliantly lit days will exceed your sensor's ability to capture it.

Exposure mode: Aperture Priority
Focal length: 14mm
Aperture: f/2.8
Shutter speed: 1/60
White balance: Cloudy
ISO: 640

Dramatic Light: One of the reasons for carrying your digital camera with you all the time is that dramatic lighting can erupt anywhere at anytime—and when it does, it literally transforms the landscape. The best time to look for drama in natural light is when a storm is approaching, or when a late-afternoon thunderstorm starts to break up.

Exposure mode: Auto
Focal length: 60mm
Aperture: f/11
Shutter speed: 1/125
White balance: Cloudy
ISO: 200

did u know?

This scene would have very bright reflections on the varnished wood and dark shadows in recessed areas of the boat if it were shot on a sunny day. The soft, diffused light of a cloudy day helped reduce the contrast considerably.

4.4 Experiment
with Existing Light

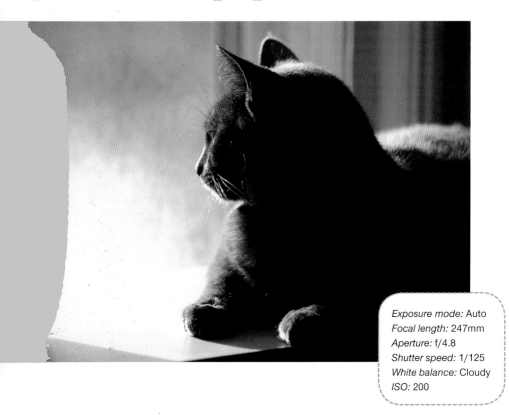

Exposure mode: Auto
Focal length: 247mm
Aperture: f/4.8
Shutter speed: 1/125
White balance: Cloudy
ISO: 200

Next time you're in a low-light scene, consider shooting by the existing light rather than using flash. Whether you want to shoot pictures of city streets at night, a stained-glass window inside a church, or even intimate portraits by candlelight, your digital camera is capable of taking wonderful photos using only the available light in a scene.

When light levels are relatively low, you will probably need to be shooting at longer shutter speeds, and a tripod will be necessary to keep the camera steady (see page 106). You might also want to use a higher ISO setting (see page 56) to increase the camera's sensitivity to light.

Existing Light Indoors

It's tempting when you're shooting indoors to use your camera's built-in flash, but using flash often destroys the atmosphere of a scene. Instead, try to work with the existing light. Portraits taken by lamplight (or even candlelight) have a much warmer, more intimate appeal than those taken with flash, and they really aren't that hard to shoot.

Here are some tips for shooting indoors using existing light:

1. Boost the ISO if your camera allows it (some cameras adjust the ISO speed automatically when they detect you're working in a dimly-lit setting).

2. Avoid including the light source itself in the shot since that will fool the camera's light meter into thinking the entire scene is brighter than it is (use exposure lock, explained on page 68, if needed).

3. Try to match the white balance (see page 86) to the type of existing light so that the colors look natural. Most lights use tungsten bulbs, so setting your white balance to the Tungsten setting will give your image natural-looking colors. Or, you can leave the white balance on the Sunny setting to intensify the warmth. (If your indoor scene has fluorescent lighting instead of tungsten, use the Fluorescent white balance setting, if available.)

4. Steady your camera! Use the arm of a couch or a tabletop if you don't have a tripod handy.

Exposure mode: Auto
Focal length: 36mm
Aperture: f/4.5
Shutter speed: 1/80
White balance: Cloudy
ISO: 200

did u know?

Shooting with existing light can be more subtle than flash, or very dramatic as seen here. Using flash to light the interior of this barn would have ruined the vivid contrast of this picture.

Exposure mode: Auto
Focal length: 14mm
Aperture: f/1.8
Shutter speed: 1/25
White balance: Auto
ISO: 200

did u know?
Some night subjects, like this Las Vegas volcano, produce quite a lot of light and can be shot hand held at relatively low shutter speeds if your camera has good image stabilization.

4.5 Fun Nighttime Photography

Considering how exotic the nighttime landscape can be, it's surprising that more photographers don't take advantage of the opportunity. I find that shooting city landscapes in particular can be both inspiring and addictive. Exposure is flexible in most night scenes; in other words, you'll get good shots at a variety of exposure settings. The great thing about shooting digitally is that you can view your experiments instantly to see if you want to use a longer exposure or look for a scene with more lights.

Here are some tips for shooting outdoor scenes at night:

1. Use a wide-angle to take in sweeping cityscapes, or use a longer telephoto zoom length to "compress" lots of lights together.

2. Use the "night time" exposure mode, if your camera has one. This will help to ensure that you're getting long enough exposures.

3. A tripod is great if you want sharp pictures, but don't avoid shooting if you don't have one handy. Sometimes jiggling the camera during a long exposure creates very interesting effects.

4. Try shooting at twilight when there is still some light in the sky but city lights have begun to come on.

5. After rain, look for streaks of color or sign reflections on wet pavement.

6. It's always fun to show the motion of car lights at night. Using a tripod or some form of support, set a long shutter speed, and capture car lights as they go streaking past.

did u know?

Long night exposures can be a lot of fun to shoot. Try setting your tripod near a busy road and experiment with different shutter speeds.

Exposure mode: Shutter Priority
Focal length: 41mm
Aperture: f/8
Shutter speed: 13.0
White balance: Auto
ISO: 100

Photo © Frank Gallaugher

4.6 White Balance:

Adjusting to the Type of Light

Digital cameras offer a quick and easy setting to adjust for different types of lighting situations, and this is called "white balance." In the film days, if you wanted your photos to look "natural," you had to match the type of film you used to the type of lighting you were shooting. Daylight film was used for outdoor photos during the day and tungsten film was used for shooting indoors. Almost all digital cameras, though, have a white balance feature that allows you to electronically adjust the sensor's response to the color of existing light. Most cameras will have a white balance (or "WB") button or, if not, it will be an option in one of the menus.

If you simply use the Auto white balance setting, the camera will automatically adjust to what it thinks is the color of the existing light.

But, in some situations, it's better to manually match the white balance selection to the type of light. Typical settings found in many white balance menus include: Sunny, Cloudy, Shade, Tungsten, Fluorescent, and Flash. Each setting, when used in conjunction with the corresponding type of light, will render the colors in your image naturally. You can also use these settings creatively to make a scene look warmer or cooler by choosing a setting that's different than the light you're shooting with. Experiment by shooting the same scene using different white balance settings and see what the effects are. Refer to your camera manual for more about your particular camera's white balance settings. They are very useful and, with a little practice, are very simple to understand and set.

Exposure mode: Auto
Focal length: 135mm
Aperture: f/8
Shutter speed: 1/1000
White balance: Cloudy
ISO: 200

did u know?

Choose white balance settings that match the lighting in the scene you are shooting. Here, the Cloudy white balance setting was chosen to warm up the light on this slightly overcast day.

 Shady WB

Cloudy WB

 Flourescent WB

☀ **Sunny WB**

Tungsten WB

⚡ **Flash WB**

did u know?

It's surprising how big a difference white balance can make in your photos. This series of pictures of a morning glory were taken within a few moments of one another, each with a different white balance setting. It was late in the afternoon when the pictures were taken so the Shade WB setting appears the most natural in terms of reproducing the actual colors. If this image were shot only in Sunny WB, it would hardly be worth keeping (unless you wanted to try to save it in post-production on the computer).

5

Using Your Flash

Electronic flash is a modern marvel; it's like having a small jug of bottled sunlight ready to uncork whenever the light gets too low. No matter how dark things get, flash can almost always provide all the light you need to get a good exposure. When I first began using electronic flash, there was still a substantial amount of distance measuring and aperture choosing involved. But today, getting a good flash exposure is as simple as just turning on the flash and shooting.

5.1 Getting the Most
from Built-in Flash

Most built-in flash units can be operated in a variety of different flash modes. Each of these modes is designed to solve a particular lighting challenge or to help achieve a creative effect. While all of the flash modes will provide adequate exposure when matched to the correct subject or situation, it's important that you understand when to use these different modes. On some cameras, you can switch between flash modes using a simple dial; on others, it's a matter of pushing a button, turning a dial, using your menu, or some combination of these three methods. (Check your camera's manual for specifics.)

Here are some of the typical modes:

Auto: In this mode, the flash will turn on automatically when the camera determines that there isn't enough existing light. Exposure is very accurate provided you stay within the flash's range.

Built-in flash couldn't be simpler to use, and in fact, on many cameras the flash will turn itself on whenever the camera detects there isn't enough existing light to get a good exposure. On other cameras, a flash indicator (typically a small lightning bolt icon) will start to blink to let you know the camera thinks it's time to use flash (and who are you to argue with what your camera thinks?).

Always On: This is more or less an override mode that tells the camera you want the flash to fire regardless of the degree of existing light. This is a good mode to turn to when you want to use fill flash (see page 96) on a bright, sunny day when the flash normally would not turn itself on.

did u know?

Sometimes all it takes is a little flash to brighten subjects that would otherwise be too dark. The first picture of the dog taken in the late afternoon is acceptable, but the subject doesn't really pop from the background. Using flash, like in the second photo, can help colors appear brighter and more saturated.

Photos © Matt Paden

Exposure mode: Aperture Priority
Focal length: 45mm
Aperture: f/6.3
Shutter speed: 1/160
White balance: Custom
ISO: 200

Red-Eye Reduction: This mode fires a pre-flash, causing the pupil to shrink, thereby eliminating most cases of red-eye (see page 94). This mode should only be used when taking portraits of people or animals in low light.

Close-Up: Some cameras have a special close-up flash mode that provides just the right amount of exposure for close-up subjects. In this mode, the typical minimum flash distance is reduced so that it doesn't overpower close-up subjects.

Slow Sync: Often when you're shooting flash pictures in dimly lit situations the flash will provide enough light for your main subject but causes the surrounding areas to fall into darkness—not a very attractive combination.

The slow-sync flash mode combines a bright flash with a longer than normal shutter speed so that the camera has time to record some of the background, thereby balancing flash and existing light.

Flash Off: There will also be times when you don't want the flash to turn on, even though the existing light is very low. If you're shooting city street scenes after dark, for example, the flash will give nearby subjects an unnaturally bright appearance. Turning the flash off means that you'll be shooting your scene using only existing light.

did u know?
If your camera offers a close-up flash mode, use it to provide an extra touch of lighting to subjects without overdoing it and causing your image to be overexposed.

Exposure mode: Auto
Focal length: 330mm
Aperture: f/5
Shutter speed: 1/60
White balance: Cloudy
ISO: 200

Exposure mode: Auto
Focal length: 28mm
Aperture: f/2.3
Shutter speed: 1/4
White balance: Auto
ISO: 125

did u know?

You camera is certainly "smart," but it's not always right. Any camera set to Auto mode would fire a flash in these low-light conditions; the result is the cool, washed out image seen to the right where the flash overpowered the ambient light. By turning the flash off, the camera was able to capture the warm atmosphere created by the candle light (above).

Exposure mode: Auto
Focal length: 28mm
Aperture: f/2.3
Shutter speed: 1/160
White balance: Auto
ISO: 100

Note:

The one thing you have to be careful of is to remain within the flash's acceptable distance range. All flashes are designed to provide adequate lighting coverage within a certain minimum and maximum distance. If you use the flash on a subject that's closer than the minimum distance, you run the risk of overpowering your subject with light; if your subject is beyond the maximum range of the flash, it will be underexposed. Read your manual to be sure you know the minimum and maximum distances for your flash.

5.2 Red-Eye Reduction is Eas

Post-Production Fixes

It may sound like a drink that Wyatt Earp might order in a Dodge City saloon, but red-eye is actually the name of that eerie red glow that eyes sometimes get when they're photographed with flash. The effect is caused by the flash reflecting off of the retinal surface of the eye, and is worst when the flash is aimed directly at the subject. You can often reduce or even eliminate red-eye by turning on additional lights if available (which causes the pupil to contract, helping to eliminate the retinal reflection), or by shooting your portrait subjects from a slightly high or low angle. Most cameras also have a red-eye-reduction flash mode that uses a series of bright preflashes to shrink the pupils of your subject's eyes—that usually solves the problem. There are even some cameras on the market that can actually eliminate red-eye in-camera after the exposure is made.

Red-eye is easy to fix with even the most basic image-processing programs. Many of the programs that come with digital cameras have a function that is specifically designed for erasing the red-eye effect. Both animals and people can get red-eye, though with animals it's often a greenish blue glow instead of a red one. A squirrel I photographed once had orange-eye.

did u know?
Trying to get rid of the evil eye? Most image-editing programs have an easy-to-use red-eye reduction feature. Here, Apple's iPhoto was used to make simple one-click corrections to the eyes.

5.3 Portable Power
with Accessory Flashes

While built-in flash is very convenient and more of a necessity than a luxury, it also has its limitations in terms of power, range, and creative flexibility. Many digital cameras can accept accessory flash units that attach via a "hot shoe" on the top of the camera (usually right above the viewfinder), and these provide substantially more flash power. An average accessory flash unit has a distance range of twice or three times that of a built-in flash. Plus, many accessory flash units have a tilt head that allows for specialized flash techniques, such as bounce flash.

If you get serious about photography, you'll soon want to learn more about lighting and using accessory flashes because they offer more power and creativity than any built-in flash. For one, you can use diffusers, modifiers, and gels over accessory flashes to change the intensity, direction, and color of the emitted light. You can also set up multiple accessory flashes off-camera that are triggered by a "master" flash unit. A multiple-light set up can add a lot of dimensionality to your photographs, and help get away from that "deer in the headlights" look common to flash pointed directly at the subject. But it's best to get comfortable with your built-in flash and perhaps one accessory unit before you worry about multiple light setups.

5.4 Easy Flash Techniques
for Better Exposures

Fill Flash

It may seem like overkill to think of using electronic flash outdoors in bright sunlight, but that is actually one of its most useful applications. The harsh light of bright sunny days causes a major problem when taking pictures of people: dark shadows in the eye sockets and under the nose, lips, and chin. By using flash in these situations, you can fill in these shadow areas with light. The idea is to use just enough flash to open the shadows; don't eliminate them entirely or the photos will look falsely lit.

Many digital cameras have a fill flash mode where the camera will automatically use just enough flash to open the shadow areas. Of course, you're still limited by the flash range (whether it's a built-in or accessory flash), but in portrait work, you will usually be working within that range anyway. If your camera does not have a fill-flash mode, just switch the flash on manually to make the camera flash in bright sunlight. Check the results on the LCD monitor and you'll see right away if your overall exposure needs adjustment.

Bounce Flash

One of the problems of using on-camera electronic flash as your primary light source indoors is that it tends to overwhelm nearby subjects while leaving more distant ones in the dark. If you're photographing your family around the holiday dinner table, for example, you end up blasting nearby faces into oblivion and underexposing more distant faces. If you have an accessory flash unit with a tilt head, however, you can use a technique called bounce flash by aiming the flash unit at the ceiling instead of directly at your subjects.

The benefit of bouncing flash from the ceiling is that it softens up the light while creating more evenly balanced illumination. Since most accessory flash units for digital cameras are dedicated TTL (through-the-lens) flash units, this means that the camera will measure the correct amount of light and shut the flash off when a good exposure has been achieved. Study your accessory flash manual for more information about bounce-flash techniques with your particular equipment.

Exposure mode: Auto
Focal length: 75mm
Aperture: f/4.5
Shutter speed: 1/320
White balance: Cloudy
ISO: 200

Photos © Kevin Kopp

Using Your Flash **97**

5.5 Common Flash Errors

Photo © Kevin Kopp

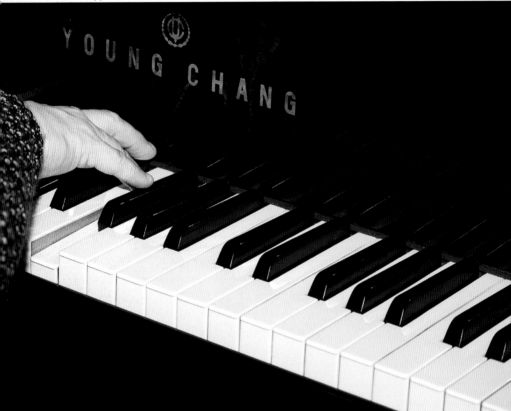

did u know?

One of the most common errors in flash photography is making it obvious that the flash was used. This is especially typical of subjects or scenes with reflective surfaces, like this piano, where the flash could easily be seen above the keys if the picture had been taken straight-on.

Exposure mode: Shutter Priority
Focal length: 80mm
Aperture: f/3.5
Shutter speed: 1/125
White balance: Auto
ISO: 100

The following chart outlines some common flash problems and quick steps for solving them:

Problem	Solution
Flash is reflecting from a glass surface or mirror	Find an angle that avoids shooting directly into the reflective surface and try shooting again.
Flash is washing out the subject	Be sure that you are observing the minimum flash distance; move away from the subject if you are too close.
The subject is too dark	You are probably shooting outside of the flash's distance range. Get closer to the subject or increase the camera's ISO. Use an accessory flash if you have one.
Members in a group of subjects are too dark	The group is spread out over too great a range. Try to arrange the group so that the members are fairly equidistant from the flash.
Subjects have red-eye	Turn on more room lights and/or activate your red-eye reduction flash mode (if available). Alternatively, shoot the subject from a high or low angle, or have the subject look away from the camera.

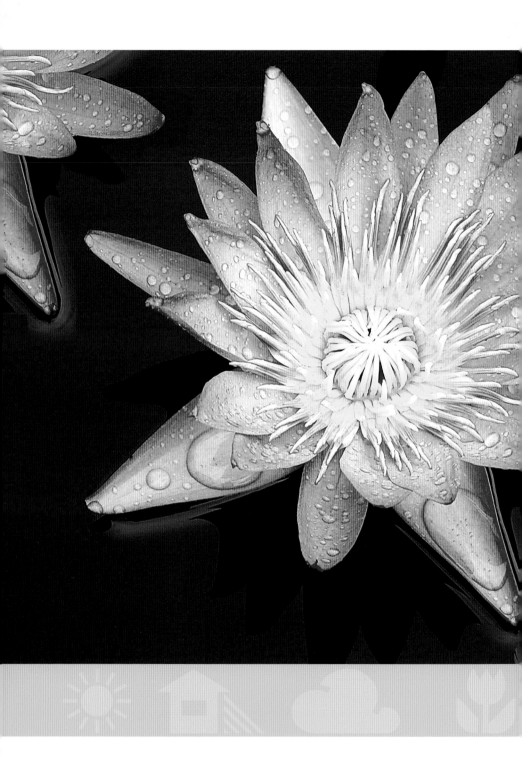

Getting
Sharper Photos

Your digital camera has a fantastically sharp lens and a very accurate autofocus system, but in order to get sharp pictures you still have to pay attention to two key things: holding the camera steady, and focusing with care. The following tips will help you to do just that.

6.1 Shooting Without a Tripod

Probably the single most frequent disappointment that most people have about their pictures is a lack of sharpness, or "blurry" shots. Most unsharp photos are due to an unsteady hand rather than a poor quality lens. In order for your pictures to look their sharpest, you have to take care to keep a steady hand when shooting.

When I was in high school I was on a rifle team and the one phrase I remember hearing literally hundreds of times is, "Squeeze the trigger, don't jerk it!" When it comes to snapping the shutter, the same thing applies: Gently put pressure on the shutter release button and you'll minimize camera shake. Also, take a deep breath and hold it as you press the shutter and you'll tame your body vibrations noticeably. Oh, and don't forget to start breathing again after you shoot the picture!

Tip

Want to know what is the slowest shutter speed at which it's safe to hand hold your camera and not get blurry images? Well, a large part of the equation depends on the focal length you will be using. Use the steps below for an easy trick to determine an approximate safe shutter speed.

1. With the camera set to Shutter Priority mode, decide on the focal length you want for your subject. Let's say it's 100mm for this example.

2. Next, we need to make sure our focal length matches a 35mm equivalent (see page 33 for more on 35mm equivalents). We need to multiply by at least 1.5; to be on the safe side, 2x multiplication is even better. Our number is now 200.

3. Make a fraction with 200 as the denominator; 1 the numerator: 1/200.

4. 1/200 is the safe shutter speed for shooting with a 100mm focal length. There will be some wiggle room here, so try a 1-stop slower shutter speed and see if it still produces sharp photos.

Note: This tip works best for cameras that don't offer vibration reduction in the lenses or camera body. Vibration reduction will allow you to hand hold the camera 2- to 3-stops slower than normal. See your owner's manual for exact details.

Stay Steady

Most of us give about as much thought to how we hold a camera as we do to how we hold a baloney sandwich. There is, however, a bit of technique involved in holding a camera if your goal is to get sharp photos. Holding a camera steady begins with your feet: Try planting your feet a few feet apart with one foot slightly forward to keep your body from swaying when you're shooting.

Since most shutter release buttons are pushed downward, it's important to support your camera from underneath with one hand while you operate the camera with the other. This technique works whether you're using the viewfinder or the LCD monitor to frame the shot. However, it is a bit easier to hold the camera steady if you're using the optical viewfinder because you can press the camera against your face.

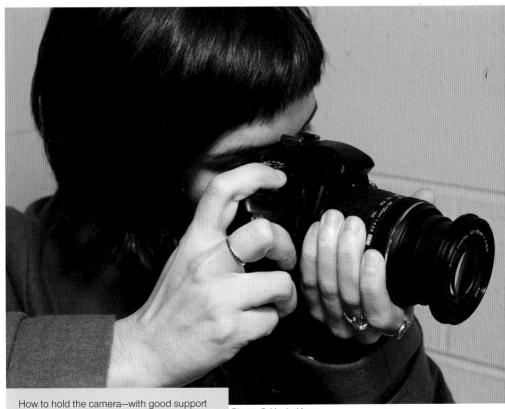

How to hold the camera—with good support from the left hand under the lens or body.

Photo © Kevin Kopp

Exposure mode: Aperture Priority
Focal length: 28mm
Aperture: f/4
Shutter speed: 1/180
White balance: Auto
ISO: 100

did u know?
It's certainly possible to get sharp photos while handholding the camera; however, it helps dramatically if you can choose a fast shutter speed.

A Good Roost

It can get tiring holding a camera for long periods, but you can ease the fatigue if you get in the habit of finding convenient supportive surfaces for your camera during shooting. Fences, cars, and porch rails all provide a steady surface that will both help you shore up your stance and can greatly extend the range of safe shutter speeds. If you just can't find a good support for the camera, you should generally keep shutter speeds at 1/60 second or faster regardless of lens focal length, unless your in-camera vibration reduction allows you to use slower speeds.

Vibration Reduction

Last but certainly not least, one of the newest and most exciting technological developments in photography in recent years is vibration-reduction technology. It was first used in expensive pro SLR lenses, but is now available in many compact and advanced digital zoom camera bodies. Also called anti-shake or image stabilization, this technology uses various computer-guided systems to eliminate camera movement and substantially increase picture sharpness at slow shutter speeds.

"
Tip: When using an uneven surface like a car hood or a rock for a camera support, you may want to use your camera's 2-second shutter delay feature, if it has one. This reduces camera shake even more by taking an unsteady push of the shutter button out of the equation.
"

Photo © Kevin Kopp

6.2 Shooting With a Tripod

Anyone who has ever taken a photo class with me will tell you that my eternal mantra is, "Use a tripod for every shot!" I realize that most people don't bother hauling a tripod around with them all the time, and there are times (like shooting the kids taking a bath) when a tripod can be more of a burden than a help. But overall, the single best way you can improve the sharpness of your pictures is to invest in a good quality, lightweight tripod and get in the habit of using it all the time. Here are some of the main advantages of using a tripod:

Tripods hold the camera rock steady at any shutter speed and make the full range of shutter speeds (and therefore apertures) available to you.

They prevent back fatigue, particularly if you're using a heavier camera model, such as a D-SLR with interchangeable lenses.

Working with a tripod slows you down, causing you to be more careful in considering design and composition.

By putting the camera on a tripod you can take multiple exposures of the same subject to try different techniques, such as experimenting with different shutter speed or aperture settings, or changing the white balance.

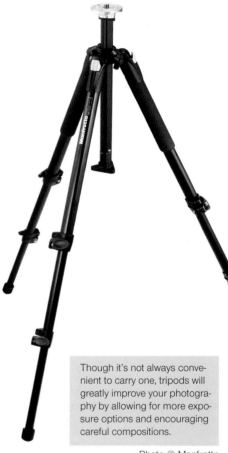

Though it's not always convenient to carry one, tripods will greatly improve your photography by allowing for more exposure options and encouraging careful compositions.

Photo © Manfrotto

When you're shooting portraits, using a tripod allows you to frame the subject carefully but then stand away from the camera and converse more naturally with your subjects. When your subject strikes a good pose, just reach over and snap the shutter.

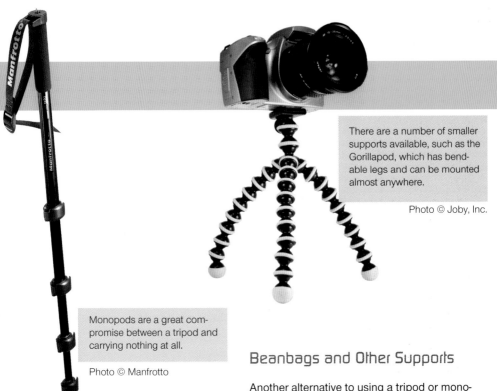

There are a number of smaller supports available, such as the Gorillapod, which has bendable legs and can be mounted almost anywhere.

Photo © Joby, Inc.

Monopods are a great compromise between a tripod and carrying nothing at all.

Photo © Manfrotto

Monopods

There are a lot of situations where using a tripod is either impractical or impossible, and a monopod is a great alternative. A monopod is a one-legged camera support, and while it won't give you the complete support that you enjoy with a tripod, you will extend your "safe" shutter speed range by several stops. I often shoot in formal gardens and house museums, for example, where tripods are generally forbidden (they don't want you tripping the other patrons, I guess), but monopods are often allowed. They are also perfect for situations like a high school graduation or a concert. Anytime there are a lot of people around and you need unobtrusive, mobile camera support, a monopod is a good choice.

Beanbags and Other Supports

Another alternative to using a tripod or monopod is to rest your camera on a homemade beanbag. You can make a beanbag for the price of a box of dried beans and a small piece of fabric. Just fashion the fabric into a small pouch, then fill it with a good quantity of dried beans or peas and seal it up. You can lay the beanbag on a rock or any other sturdy surface, then "nest" your lens or camera body into it.

There are other creative tripods and camera supports made by a number of manufacturers. Take the time to explore and see what kind of gear best fits your shooting needs. One cool tripod gadget is the Joby Gorrilapod. This miniature tripod has bendable legs that can wrap around tree limbs, fence posts, and just about anything else, for shooting from creative angles.

6.3 Auto Focus

In most situations, you can simply aim and shoot and rely on the camera to provide a sharply focused picture. Good as it is though, having a basic understanding of how autofocus systems work, and how you can manipulate them, will help your photography. On many digital cameras, you will see a pair of rectangular brackets in the center of the viewfinder (or on the LCD monitor) during shooting that indicate where the camera is focusing. It's important that you place these focus brackets over your main subject—a person's face if you're shooting a portrait, for example—so that the camera focuses on the correct part of the scene. A common mistake is to have the indicators on the background instead of on your main subject, and what you end up with is exactly that: a beautifully focused background and an out-of-focus main subject.

On many cameras, the autofocus brackets will adjust themselves automatically to try and closely match what the camera thinks your primary subject is. You'll notice that as you alter your composition—changing from a small central subject to a much wider off-center one, for example—the indicators will widen in order to try and focus on the important parts of the scene.

For D-SLRs, compact zoom cameras, and some advanced point-and-shoots, you'll often see focus points through the viewfinder rather than just brackets. The number and orientation of the focus points will depend on the camera model (with high-end models offering more points), but they all work basically the same by offering a number of focus points across the scene. Often, when you press the shutter button halfway you'll see which of the autofocus points are in use—they usually blink once over what the camera perceives to be the subject of the picture, and thus the area of focus. You can usually manually select these focus points, too. This becomes helpful for compositional choices. If your subject happens to be in the top right corner of your composition, you can choose to use only the focus point there.

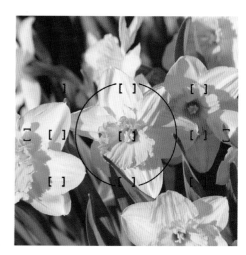

did u know?

Autofocus technology has come a long way since its inception. It can now be relied on to capture fantastically sharp focus and details for almost every picture.

Exposure mode: Auto
Focal length: 135mm
Aperture: f/4.5
Shutter speed: 1/320
White balance: Auto
ISO: 200

6.4 Autofocus Savvy

There are a couple more good things to know about autofocus if you have an advanced camera. First, did you know you can change between single point AF and continuous AF? Single point AF only allows the camera to take a picture once focus has locked onto something. You'll want to use this AF option most of the time, but it can be difficult with moving subjects. Continuous AF lets the camera shoot as it is focusing, which is great for sports and fast wildlife shots. The second thing to know is that your camera might have problems using autofocus in dim conditions. Some cameras have an autofocus assist beam that will emit a bright burst of light to help the camera gain focus. However, beware of using the autofocus assist light in places where it could be rude or possibly even dangerous. See the list on page 113 for more solutions to this problem.

Note:

Virtually all D-SLR cameras (and some advanced digital zoom cameras) have a manual focusing capability, which lets you focus the camera either by turning the lens barrel itself or by using a focusing switch. Manual focus is a great option when the camera is having difficulty focusing with its AF system, or when you have a very small but important target in a complex scene—one face in a crowd, for example.

Exposure mode: Auto
Focal length: 60mm
Aperture: f/6.3
Shutter speed: 1/160
White balance: Sunny
ISO: 1600

I took this picture of candles in the Notre Dame cathedral in Paris. The flash and AF assist light were turned off so there would be no rude burst of light.

6.5 Autofocus Lock

Exposure mode:
Aperture Priority
Focal length: 157mm
Aperture: f/11
Shutter speed: 1/160
White balance: Cloudy
ISO: 200

did u know?
Placing your subject off center keeps things interesting, and using focus lock ensures the interesting part of your picture is suitably sharp.

Having all of your important subjects dead center in the frame is not the most artistically inspired design plan. For the sake of an interesting composition, you might want to place your main subject off-center— either to the left, right, top, or bottom (or some combination of these possibilities). In order to let you do this while still maintaining focus, most digital cameras have an autofocus lock that is activated by pressing the shutter release halfway down.

Follow these three simple steps when focusing on an off-center subject:

1. Position your key subject in the center of the frame and press the shutter release button halfway down to activate the autofocus.

2. Without lifting your finger from the shutter release button, recompose your scene so that the subject is where you want it in the frame.

3. Press the shutter release button down completely to take the picture.

6.6 Difficult Autofocus Subjects

Exposure mode: Aperture Priority
Focal length: 99mm
Aperture: f/14
Shutter speed: 1/13
White balance: Cloudy
ISO: 200

did u know?

Scenes containing fog and mist create problems for auto-focus systems because they lack the contrast that digital cameras need to find sharp focus. Look for a spot of contrast to help you focus or switch to manual focusing.

As reliable as autofocus is, there are some situations where your camera may have trouble finding a sharp point of focus. Use the following solutions for these occasions:

Autofocus Troubleshooting

Problem	Solution
Low Contrast: Many AF (autofocus) systems use scene contrast to help them focus, so a scene with very low contrast may present focusing difficulties.	Look for a contrast edge where dark and light areas meet and position the focus indicator brackets over this distinct point of contrast. (Refer back to page 111 for details on how to maintain focus while you recompose the shot.)
Fog and Mist: Fog and mist reduce contrast in landscape scenes, making it hard for the camera to find a good focusing point.	Look for a dark subject—such as a tree or a sailboat—penetrating the fog or mist and focus on that.
Low Light: AF systems are designed to operate in low light, but in very dark situations the camera may have trouble locking focus. Many cameras have a focusing illuminator beam that sends out a grid of light that the camera "sees" and can focus on. Typically, however, the illuminator beam can only reach a distance of 12-15 feet (3.7-4.6 m), so its usefulness is limited to nearby subjects.	If possible, turn on more lights to raise the light level or use the camera's built-in flash. Try to find a bright subject—a lamp, for example—that is the same distance from the camera as your subject and pre-focus on that area. Then, use your focus-lock feature (if available) to maintain focus while you recompose the shot.

6

Problem	Solution
Moving Subjects: Moving subjects can be hard to focus on because your camera is designed to lock focus on stationary subjects. Some cameras, however, have a "continuous" focus mode that continually refocuses up to the instant of exposure.	Be sure to keep moving subjects within the focus-indicator brackets. Switch to a continuous-focus mode if your camera has one. (See page 110 for more about action photography.)
Patterns: Some AF systems are better at focusing on patterns than others (fence rails, for example). You may find that your camera balks when trying to latch focus onto a particular pattern.	Turn your camera on a slight angle so that the pattern takes a different position in the viewfinder. If that doesn't work, look for a small area of the composition that doesn't contain the pattern and focus on it, then recompose the shot.
"Blank" Areas: As sophisticated as it is, your camera can't focus on subjects with no details or contrast—such as a black cat in front of a dark wall.	Find an area with detail approximately the same distance from the camera as your primary subject and position your focus indicator brackets over that area. If you're photographing a black cat in front of a dark wall, for instance, be sure the focus indicators are over the cat and not the wall.
Shooting Through Glass: The problem with shooting through glass is that your camera will try to focus on the glass itself if there are any smudges or dirt on the surface. Reflections can be a problem, too. (Ironic, isn't it? Sometimes you can't get a camera to focus on a tree in the fog, but it can manage to find a finger smudge on glass.)	Be sure the glass is clean, then get as close to the glass as you can so that the camera isn't trying to focus on reflections. If your camera can take filters, use a circular polarizer, which can eliminate reflections. If you have a D-SLR, switch to manual focus.

Photo © Matt Paden

Exposure mode: Aperture Priority
Focal length: 45mm
Aperture: f/5.0
Shutter speed: 1/160
White balance: Auto
ISO: 100

did u know?

Sometimes a camera's AF system will have trouble finding focus in patterns, or it may lock focus in the wrong part of the patterned scene. About 15 test shots of this frosted window were taken from different distances and angles until acceptable focus was achieved in the important parts of the image. Switching to manual focus may have helped solve the problem as well.

7

Composition & Style

Great pictures are about more than merely knowing how to use your camera—they are also about having interesting visual ideas. If all it took to take great pictures was to have an expensive camera, the world would be overrun with wonderful photographers! In this chapter, we'll take a look at some of the concepts that go into designing great images and putting your creative musings to work. Remember, when it comes to creative ideas, there are no rights or wrongs and there are no rules—but there are lots of tips and tricks to help you put your ideas into action.

Photo © Kevin Kopp

7

7.1 Think Like an Artist

When Composing Shots

Countless books have been written about artistic composition and design, but all the elaborate theories in the world come down to one simple thought: Composition is the art of arranging things within the frame so that they have the strongest impact. Let's look at some simple methods for doing just that.

Choose a Strong Center of Interest: A photograph should be about one thing: a barn, a person, a piano, or even a person sitting at a piano in front of a barn. However, if you also include a cow and a farmer in that shot, you may have people wondering what you were trying to show. Be specific. You should be able to describe your photo in a very simple sentence: "This is a photograph of my cat sleeping in the window," rather than, "This is a photograph of my cat sleeping in the window next to my husband sitting in his favorite chair... and please ignore the pile of magazines on the floor next to him." Keep it simple. It should be easy for anyone looking at the photo to tell what your subject is.

Exposure mode: Aperture Priority
Focal length: 270mm
Aperture: f/6.3
Shutter speed: 1/80
White balance: Cloudy
ISO: 200

Exposure mode: Auto
Focal length: 180mm
Aperture: f/5.6
Shutter speed: 1/250
White balance: Cloudy
ISO: 200

did u know?
Avoid creating static scenes by using a slightly off-center subject placement. By placing this boat above the center line and keeping the foreground simple, the eye is drawn upward into the frame.

Place the Subject with Care: It's so easy (and natural) to put a subject in the center of the frame that most people do just that. Like an archer going for a bull's eye, we nail the subject to the middle of the frame. But centering your subject creates equal amounts of space around it and that makes for a very static design. Instead, try to place your main subject high or low in the frame, or to the left or right. The slight imbalance created by off-center subjects lures the eye into exploring the scene. Most commonly, photographers rely on the "rule of thirds" for off-center compositions. Imagine your picture divided in thirds from side to side. Now imagine it divided in thirds from top to bottom as well. You should now be seeing a picture divided into nine equal segments, and the four corners where these segments meet are often a good spot to place your subject to make an interesting composition.

Exposure mode: Manual
Focal length: 24mm
Aperture: f/4
Shutter speed: 1/640
White balance: Auto
ISO: 100

Simplify: The fewer things you include in the frame, the more powerful the things you do include become. Try to eliminate anything that distracts from your main subject.

Get Closer: One of the best ways to eliminate clutter and focus attention on your main subject is to simply move closer. As long as you're not shooting sailboats from the end of a wharf, take a few steps closer and you will improve your images greatly. If you can't move closer physically, try using a longer zoom setting.

Use Frames within Frames: One trick that many landscape photographers use to eliminate distracting surroundings and focus attention on a subject is to surround it with an existing frame in the scene. Look for both natural frames (tree branches, rock formations) and manmade frames that have a thematic link to your main subject—framing a cow in a barn doorway, for example.

Place Horizons to Emphasize Space:
Where you place the horizon has a tremen-
dous effect on how the division of space
in the scene will be perceived. Placing the
horizon low in the frame emphasizes the
sky; placing the horizon higher in the frame
exaggerates foreground space. Most how-to
books on composition will tell you to avoid
putting the horizon across the center of the
frame because it tends to create that static
feeling I mentioned earlier when the space
around your subject is divided equally. And
that's true, but sometimes centering the
horizon just seems to work in a particular
composition, and the symmetry creates a
pleasing sense of balance. Experiment with
horizon placement for yourself and see what
you think.

Exposure mode: Manual
Focal length: 34mm
Aperture: f/4
Shutter speed: 1/400
White balance: Auto
ISO: 200

did u know?
Placing your main subject high in the frame
emphasizes distance to the subject by exagger-
ating the foreground space. Here the series of
"stepping stones" in the water heightened the
perception of depth even more.

7.2 Create Clutter-Free Images

One of the simplest ways to fortify most compositions is to crop away extraneous details—anything that doesn't add to an image detracts from it. If you've photographed a father and daughter on the shore, for instance, you don't need to show the expanse of sand and water around them. By cropping away superfluous material, you focus your viewer's attention on your main subject and eliminate doubts about what it is you're trying to show.

Cropping can be done to any size or shape, and it's perfectly fine to crop a rectangular photo into a square one or turn a normal landscape into a panoramic. But beware! When you crop a digital image, you're throwing away pixels and reducing the maximum size print you can make. If a file was originally large enough to make a quality 8 x 10-inch print (A4), for example, and then you crop half of it away, you either have to settle for a smaller print or a larger print at a lower resolution. Be sure to save your original un-cropped file just in case the cropped image doesn't print as well as you would like.

did u know?

Cropping puts the attention where it should be in your photos—on the subject. By cutting out extraneous details or information, the image becomes more focused. The subject will also become larger in the frame thanks to cropping.

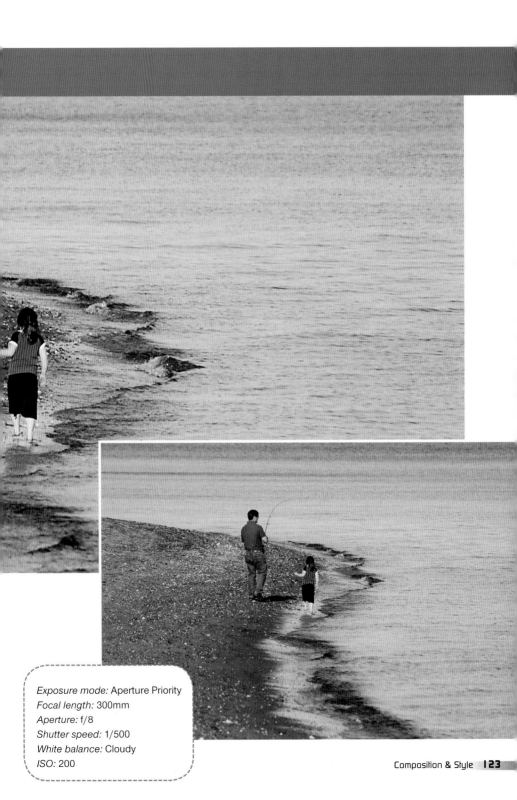

Exposure mode: Aperture Priority
Focal length: 300mm
Aperture: f/8
Shutter speed: 1/500
White balance: Cloudy
ISO: 200

7.3 Take Horizontal
& Vertical Shots

Just because your camera is designed to be held more comfortably in the horizontal position doesn't mean you won't improve your compositions by shooting vertically on occasion. In fact, lots of subjects—tall buildings, flowers, a baseball player reaching up for a fly ball—just look better when shot vertically. Often, it helps to shoot a subject both ways and decide later which is better, once you've downloaded the images. And don't forget, you can always crop a horizontal shot vertically and vice versa—these are your photos! You get to decide what looks best.

Exposure mode: Shutter Priority
Focal length: 28mm
Aperture: f/8
Shutter speed: 1/250
White balance: Sunny
ISO: 100

did u know?

I probably looked pretty curious to most of the other tourists laying on my back to get this shot, but sometimes you have to go to extremes to find a new angle on a familiar subject.

7.4 Try an Extreme Angle

People are delighted by the unexpected—that's one of the concepts that all writers, photographers, artists, and other creative types use to their advantage. Visually, you can surprise people by showing them a subject from an angle they may never have thought of before. Have you ever laid on the ground and looked up at a dandelion? Have you (brave soul that you are) climbed a mast to look back down at the deck of a sailboat? You needn't get so extreme in finding unusual vantage points, but next time you're shooting a familiar subject (like your kids hanging out on the backyard swings) try finding a perspective that is totally unexpected. At the very least, you'll take people by surprise—maybe even yourself—and that's half the fun of taking creative pictures.

7.5 Exploit Design Elements

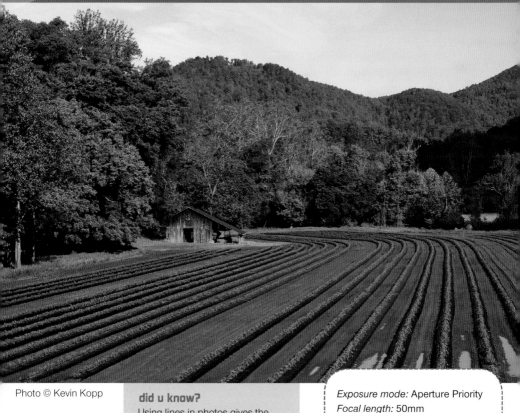

Photo © Kevin Kopp

did u know?
Using lines in photos gives the viewer's eyes something to follow through the image. In this case, they lead straight to the old barn, which acts as a nice visual destination.

Exposure mode: Aperture Priority
Focal length: 50mm
Aperture: f/11
Shutter speed: 1/125
White balance: Sunny
ISO: 100

To the average person, a tropical landscape might be made up of a long curving beach, a rocky jetty, a few palm trees, and a sailboat sailing into the sunset. But to photographers, that same scene is made of up lines (the beach), textures (the rocks), shapes (the trees and sailboat), and colors (the sunset). Learning to spot the visual elements hidden in common objects will greatly enhance your design sense and your ability to organize very complex scenes. Let's take a quick look at the five most basic design elements.

Exposure mode: Aperture Priority
Focal length: 60mm
Aperture: f/5.6
Shutter speed: 1/10
White balance: Auto
ISO: 100

did u know?

Highlighting textures in your photos can engage a viewer's sense of touch (even though it's still a two-dimensional image!).

Photo © Kevin Kopp

Lines: Like a twisting country road leading to a pretty covered bridge, lines lure us deeper into a scene and give us a roadmap for the ride. Our eyes have a natural curiosity towards lines that makes it almost impossible not to follow them to their destination.

Shapes: Like a circle drawn in the sand, when a line joins up with itself it becomes a shape, and shapes are one of the most primal ways we have of identifying objects. You don't need to see the face of a person silhouetted on the beach to know that it's a person—and if that shape is familiar enough, you might not even need a face to be able to recognize who that person is.

Color Contrasts: The clashing of brilliant colors can be a very powerful design element, largely because colors stimulate the imagination. The key to capturing strong contrasts is to eliminate everything but the colors.

Textures: Textures describe the surface of a subject. Virtually all objects—both large and small—have an inherent texture: gravel paths, burlap sacks, and the rough hewn surface of barn wood are all textures that we know. In fact, some textures are so real to our imaginations—like the smooth slippery surface of seaweed on rocks—that we know exactly how it will feel when we actually touch it (or what it will feel like when we slip off of it!).

Patterns: Whenever any of the design elements repeat themselves in some way, a pattern is born. To capture patterns, move in close and eliminate everything but the repetition.

8

Beyond the Camera

Unlike the days when processing your own pictures meant converting your laundry room into a makeshift dark-room, the real beauty of digital pho-tography is that all you need to view, edit, or share your images is a personal computer. You can also print and enlarge your own images using a desk-top printer, upload your pictures to an online lab to order prints, or take your memory cards to your local photo store and let them print your photos for you. Working with digital images is fast, clean, fun, and best of all, you don't have to spend your week-ends hanging out in your laundry room (unless you're doing laundry, of course).

8.1 Transferring Your Images

Once you have your photos stored on a memory card, you will need to save them elsewhere. You will want to get photos off the card so they can be used in other applications, and also to clear your card for reuse.

Downloading from the Camera

Nearly all digital cameras offer the ability to transfer images directly to the computer with a connection from the camera. However this may not be the best way to transfer data, because it can deplete your camera's battery, among other factors. Downloading usually involves a cable (typically a USB connection), although WiFi image transferring is a feature starting to appear in some cameras.

You don't need to remove the card from the camera when you use your camera for downloading. You simply connect one end of the USB cord to a USB port on the computer and the other end to the camera's USB port. When you turn on the camera, computers with the latest operating systems will usually recognize it and help you make the transfer. If not, you'll have to add the camera's software.

Depending on what imaging programs you have on your computer (and the camera's software), you'll often find a program to help you move photos onto the hard drive. At this point, the digital image files are being copied from one place (your camera) to another (your computer).

did u know?
Image browser software like Apple's iPhoto will help you download and organize your files. Photo © Apple Inc.

Note:
Pay careful attention to where these files are going. Too often the files end up somewhere on the hard drive-but where? If it is not clear, the program will usually tell you in Options, Preferences, or Tools.

Photo © Apple, Inc.

Card Readers

I strongly recommend a card reader for downloading. This is the fastest and simplest method. A card reader is a small, stand-alone device that plugs into the computer (via USB or FireWire), and it has a slot for your camera's memory card. Many of these devices will read multiple card types—this can be a real benefit if you have more than one camera and they use different cards. Otherwise, you will probably just want the simple, less expensive unit that only reads the type that your camera uses.

A card reader is easy to use and very affordable. In a way, it makes your camera act like a traditional film camera. You simply take your "digital film" out of the camera and put it into the slot for "processing." The computer will recognize the card as a new drive (on some older operating systems you may need to install a driver for the card reader, which will be on software that comes with the unit).

The card reader now allows you to manage the image files. If you are not familiar with how computers deal with files, transferring images may take some learning. But if you have even basic computer skills, you will find that this reader now allows you to work with the image files just as you would any other files—like selecting all the photos on the card and copying them to a new folder on your hard drive.

Here are some simple steps for downloading your images:

1. Set up a folder on your hard drive to hold your transferred photos (you can name it something related to your photos, such as Soccer Tournament July).

2. Plug in your card. When it appears on your desktop (maybe with a downloading wizard), open the folder and find the photos.

3. Select all the photos (Command/Ctrl A).

4. Drag and drop them to the folder you set up (this will copy them there).

5. Use a browser program such as ACDSee or iPhoto (Mac) to review, edit, and sort your photos. There are many such programs available.

8.2 Organizing Your Images

Once you get into the swing of shooting digitally, you're going to be surprised by how fast all of those digital photos add up. Even shooting just ten photos a week turns into 500+ photos in a year's time! Keeping track of your pictures and being able to find them when you want them requires some good organizational skills and regular computer housekeeping on your part. Fortunately, there are a number of terrific and simple-to-use organizational software products on the market (many of which are free) that will help you caption, label, and file your digital photos in a methodical and organized way.

If you decide to try to keep everything organized by yourself, without the help of software, be sure that you are consistent about filing and captioning your photos. Just how successful your digital photo organization will be depends on how methodical you are about sticking to your particular organizational system. Truly, the key to staying organized is taking advantage of the software that you have installed, and then sticking by your plan. Many times, the software that came with your camera will have organizational capabilities, and all you have to do is tap into them. Features like keyword searching and caption searching make finding any image very simple. By giving each photo that you download a few succinct keywords, like "Arizona, Sunset, 2009," for example, even if you forget where the photo is, you'll be able to find it by doing a keyword search.

did u know?

It's very helpful to use image-browsing software like Apple's iPhoto, which helps you keep photo files organized

Photo © Apple Inc.

In many programs, when you download a batch of new images, they are entered into a "library" that contains all of the digital images you've downloaded. At the time of download, you can create a subfolder for a particular group of photos. For example, suppose you download 100 photos from your trip to Connecticut's Mystic Seaport. Just create a folder named "Mystic Seaport, June 2009" and those photos will appear both in the main library and in a list of alphabetical folders. As long as you can remember the name of the place, or the year or month that you were there, you'll find the pictures instantly.

The most important thing to remember with any organizational system is to follow good intentions with great follow-through. Take the time to create folders and to designate keywords to individual photos (or groups of photos) at the time of download because you will never go back and do it later.

Sending Photos with Email

The ability to email your photos instantly to family and friends around the world is extraordinary. In just seconds, your pen pals on another continent can be enjoying the photos you just shot. Because digital photo files can be very large, however, it's important that you follow some simple steps in order to prepare your images for fast and easy emailing. If you send friends huge files that take forever to download, they're going to avoid opening your mail—so take the time to prepare the images correctly.

Here are some simple steps for emailing your images:

1. Open the image that you want to send in your image-processing software program. If you don't have one, check out www.gimp.org, which offers a free program.

2. Select the Image Size or Image Resize option from your toolbar.

3. Rename the image and then save it with its new name so that you don't overwrite the original.

4. Set the image resolution to 72 ppi, which is fine for virtually all monitors.

5. Set the image dimensions to 4 x 6 inches (A6) or 5 x 7 inches (A5), then click Save.

6. Open your email program and use the Attach File button or command to attach the file to your email. Some programs will display the image in the message area, others require the recipient to download and save the image file.

8.3 Making Prints

Printing with an Inkjet Printer

There is no greater thrill in digital photography than seeing a big beautiful 8 x 10-inch print (A4) come rolling out of your printer in just minutes. The first time I made a color print on my home computer (of a rose in my garden) I was so excited I nearly ran down the street singing—it was that exciting! Home inkjet printing is not a difficult skill to master—it just takes some practice and a bit of patience. Almost any decent-quality inkjet printer will make acceptable prints, but if you're buying a printer specifically for printing digital images, look for one that says "photo quality" in the description.

Usually you'll want to send your image file from your computer to the printer. But Pict-Bridge compatible printers will allow you to print directly from the memory card, which can be very convenient.

Using a Photo Lab

Don't let being intimidated by computers or printers stop you from getting nice prints! Simply pop the memory card out of your camera and leave it at the lab just as you would with film. Labs can make prints, burn your pictures to CD, or even set up an online gallery of your photos so you can share them with friends around the world.

Online Photo Services

Another alternative to making prints yourself is to use the services of an online digital lab. Internet-based labs can transform your digital files into beautiful prints and enlargements, then return them to you in just a few days. All you do is upload your digital files from your computer to their site and tell them the size and number of prints that you want. Online labs are great for printing large numbers of prints, or for making extra-large prints that are too big for your desktop printer.

Online Photo Galleries

Many online digital photo labs also offer free online gallery space so that you can share your photos with friends and relatives around the world. Galleries are often password protected so that only the people you invite can view them. One of the great things about online labs is that your family and friends can view the pictures at home and then choose the photos they like and order prints directly. Imagine attending a family reunion and then posting your photos to an online gallery— family members from near and far can order just the pictures they want and in any quantity and size they want. It's a really great way to share pictures and save money.

Photo © Epson

> **did u know?**
> Like many photo printers, this one is PictBridge compatible, which means you can print pictures straight from the memory card without downloading to the computer first.

8.4 Archiving Your Images

One of the realities of digital imaging is that (compared to word processing files or email files, for example) digital image files take up an enormous amount of memory space. Even if you're selective about which images you keep and are good at computer housekeeping, eventually you'll clog your entire hard drive if you don't move some of the images off of the computer. Even if you don't shoot that many digital photos, it's a good idea to back them up onto media that exists outside of your computer. That way if your computer crashes, you won't lose all your photos.

Tip

Serious hobbyists and pros back up their photos in two or more physical locations. Consider keeping an archive of all your important images at a family member's house or rented storage unit (if you already use one).

The simplest method for archiving your important images is to burn them to a DVD. DVDs are an inexpensive and reliable method for storing significant numbers of photos, and they hold many more images than CDs. If you're not familiar with how to burn a DVD, read your computer manual to see what you need to do. The procedure is very simple. It only takes a few minutes, and it can spare you a great deal of agony if your hard drive crashes and takes your images with it.

External hard drives are, of course, another option. These drives have come down in price considerably in the past few years and they offer huge amounts of capacity in the hundreds of gigabytes. The downside is that all hard drives are susceptible to crashing at some point, so if you choose this backup route, you may want to store images on more than one drive.

Photo © Western Digital

did u know?

Storing your digital image files can take up a lot of room, and you want to make sure they stay protected. Use multiple back up hard drives or archival DVDs to insure you never lose your work.

8.5 Image Processing

Sky not blue enough? Mountains not sharp enough? Litter ruining your pristine beach scene? Fear no more. Basic image-processing programs can solve these and thousands of other technical and creative dilemmas. There are also good software programs that sell for less than $100 and offer many of the same capabilities as professional programs costing several times as much.

Indeed, if there is one thing above all else that sets digital imaging apart from film photography, it's the ability to easily correct and enhance your photographs. While it does take practice and a certain amount of devotion like any other hobby, you'll be surprised by how fast you learn the tricks of image pro-

cessing once you apply yourself on a regular basis. And some software fixes, like correcting red-eye in portraits, take literally just a second or two—anyone can learn to do it.

Creative Image Manipulation

For many digital photographers, creativity begins where the camera leaves off, and the real fun begins in the computer. The same image-processing tools that are used to correct flaws and enhance reality can be exploited to create strange and fanciful visions. If things like butterflies with melting wings and pink cows standing in Times Square turn you on, you're going to love the potential of creative image manipulation.

> **did u know?**
> Creative image manipulation is easy with photo programs. Basically, if you can think it up, you can make it happen on the computer with enough practice and know-how.

Glossary of Terms

angle of view
The area seen by a lens, usually measured in degrees across the diagonal of the film frame.

aperture
The opening in the lens that allows light to enter the camera. Aperture is usually described as an f/number. The higher the f/number, the smaller the aperture; and the lower the f/number, the larger the aperture.

Aperture-priority mode
A type of automatic exposure in which you manually select the aperture and the camera automatically selects the shutter speed.

artifact
Information that is not part of the scene but appears in the image due to technology. Artifacts can occur in film or digital images and include increased grain, flare, static marks, color flaws, noise, etc.

artificial light
Usually refers to any light source that doesn't exist in nature, such as incandescent, fluorescent, and other manufactured lighting.

automatic exposure
When the camera measures light and makes the adjustments necessary to create proper image density on sensitized media.

automatic flash
An electronic flash unit that reads light reflected off a subject (from either a preflash or the actual flash exposure), then shuts itself off as soon as ample light has reached the sensitized medium.

automatic focus
When the camera automatically adjusts the lens elements to sharply render the subject.

available light
The amount of illumination at a given location that applies to natural and artificial light sources but not those supplied specifically for photography. It is also called existing light or ambient light.

backlight
Light that projects toward the camera from behind the subject.

bit depth
The number of bits per pixel that determines the number of colors the image can display. Eight bits per pixel is the minimum requirement for a photo-quality color image.

bracketing
A sequence of pictures taken of the same subject but varying one or more exposure settings, manually or automatically, between each exposure.

buffer
Temporarily stores data so that other programs, on the camera or the computer, can continue to run while data is in transition.

built-in flash
A flash that is permanently attached to the camera body. The built-in flash will pop up and fire in low-light situations when using the camera's automated exposure settings.

built-in meter
A light-measuring device that is incorporated into the camera body.

bulb
A camera setting that allows the shutter to stay open as long as the shutter release is depressed.

CCD
Charge Coupled Device. This is a common digital camera sensor type that is sensitized by applying an electrical charge to the sensor prior to its exposure to light. It converts light energy into an electrical impulse.

CMOS
Complementary Metal Oxide Semiconductor. Like CCD sensors, this sensor type converts light into an electrical impulse. CMOS sensors are similar to CCDs, but allow individual processing of pixels, are less expensive to produce, and use less power. See also, CCD.

CMYK mode
Cyan, magenta, yellow, and black. This mode is typically used in image-editing applications when preparing an image for printing.

color balance
The average overall color in a reproduced image. How a digital camera interprets the color of light in a scene so that white or neutral gray appear neutral.

color cast
A colored hue over the image often caused by improper lighting or incorrect white balance settings. Can be produced intentionally for creative effect.

color space
A mapped relationship between colors and computer data about the colors.

compression
A method of reducing file size through removal of redundant data, as with the JPEG file format.

contrast
The difference between two or more tones in terms of luminance, density, or darkness.

contrast filter
A colored filter that lightens or darkens the monotone representation of a colored area or object in a black-and-white photograph.

critical focus
The most sharply focused plane within an image.

cropping
The process of extracting a portion of the image area. If this portion of the image is enlarged, resolution is subsequently lowered.

dedicated flash
An electronic flash unit that talks with the camera, communicating things such as flash illumination, lens focal length, subject distance, and sometimes flash status.

default
Refers to various factory-set attributes or features, in this case of a camera, that can be changed by the user but can, as desired, be reset to the original factory settings.

depth of field
The image space in front of and behind the plane of focus that appears acceptably sharp in the photograph.

dpi
Dots per inch. Used to define the resolution of a printer, this term refers to the number of dots of ink that a printer can lay down in an inch.

electronic flash
A device with a glass or plastic tube filled with gas that, when electrified, creates an intense flash of light. Also called a strobe. Unlike a flash bulb, it is reusable.

electronic rangefinder
A system that utilizes the AF technology built into a camera to provide a visual confirmation that focus has been achieved. It can operate in either manual or AF focus modes.

EV
Exposure value. A number that quantifies the amount of light within an scene, allowing you to determine the relative combinations of aperture and shutter speed to accurately reproduce the light levels of that exposure.

EXIF
Exchangeable Image File Format. This format is used for storing an image file's interchange information.

exposure
When light enters the camera and reacts with the sensitized medium. The term can also refer to the amount of light that strikes the light sensitive medium.

file format
The form in which digital images are stored and recorded, e.g., JPEG, RAW, TIFF, etc.

filter
Usually a piece of plastic or glass used to control how certain wavelengths of light are recorded. A filter absorbs selected wavelengths, preventing them from reaching the light sensitive medium. Also, software available in image-processing computer programs can produce special filter effects.

firmware
Software that is permanently incorporated into a hardware chip. All computer-based equipment, including digital cameras, use firmware of some kind.

flare
Unwanted light streaks or rings that appear in the viewfinder, on the recorded image, or both. It is caused by extraneous light entering the camera during shooting. Filters can also increase flare. Use of a lens hood can often reduce this undesirable effect.

focal length
When the lens is focused on infinity, it is the distance from the optical center of the lens to the focal plane.

focal plane
The plane on which a lens forms a sharp image. Also, it may be the film plane or sensor plane.

focus
An optimum sharpness or image clarity that occurs when a lens creates a sharp image by converging light rays to specific points at the focal plane. The word also refers to the act of adjusting the lens to achieve optimal image sharpness.

f/stop
The size of the aperture or diaphragm opening of a lens, also referred to as f/number or stop. The term stands for the ratio of the focal length (f) of the lens to the width of its aperture opening. (f/1.4 = wide opening and f/22 = narrow opening.) Each stop up (lower f/number) doubles the amount of light reaching the sensitized medium. Each stop down (higher f/number) halves the amount of light reaching the sensitized medium.

full-frame sensor
A sensor in a digital camera that has the same dimensions as a 35mm film frame (24 x 36 mm).

GB (gigabyte)
Just over one billion bytes.

gray card
A card used to take accurate exposure readings. It typically has a white side that reflects 90% of the light and a gray side that reflects 18%.

gray scale
A successive series of tones ranging between black and white, which have no color.

guide number (GN)
A number used to quantify the output of a flash unit. It is derived by using this formula: GN = aperture x distance. Guide numbers are expressed for a given ISO film speed in either feet or meters.

histogram
A graphic representation of image tones.

hot shoe
An electronically connected flash mount on the camera body. It enables direct connection between the camera and an external flash, and synchronizes the shutter release with the firing of the flash.

image-processing program
Software that allows for image alteration and enhancement.

interpolation
Process used to increase image resolution by creating new pixels based on existing pixels. The software intelligently looks at existing pixels and creates new pixels to fill the gaps and achieve a higher resolution.

IS
Image Stabilization. This is a technology that reduces camera shake and vibration. It is used in lenses, binoculars, camcorders, etc.

ISO
From ISOS (Greek for equal), a term for industry standards from the International Organization for Standardization. When an ISO number is applied to film, it indicates the relative light sensitivity of the recording medium. Digital sensors use film ISO equivalents, which are based on enhancing the data stream or boosting the signal.

kilobyte (KB)
Just over one thousand bytes.

latitude
The acceptable range of exposure (from under to over) determined by observed loss of image quality.

lens hood
Also called a lens shade. This is a short tube that can be attached to the front of a lens to reduce flare. It keeps undesirable light from reaching the front of the lens and also protects the front of the lens.

light meter
Also called an exposure meter, it is a device that measures light levels and calculates the correct aperture and shutter speed.

macro lens
A lens designed to be at top sharpness over a flat field when focused at close distances and reproduction ratios up to 1:1.

main light
The primary or dominant light source. It influences texture, volume, and shadows.

Manual exposure mode
A camera operating mode that requires the user to determine and set both the aperture and shutter speed. This is the opposite of automatic exposure.

Mbps
Megabits per second. This unit is used to describe the rate of data transfer.

megabyte (MB)
Just over one million bytes.

megapixel
A million pixels.

menu
A listing of features, functions, or options displayed on a screen that can be selected and activated by the user.

middle gray
Halfway between black and white, it is an average gray tone with 18% reflectance. See also, gray card.

midtone
The tone that appears as medium brightness, or medium gray tone, in a photographic print.

mode
Specified operating conditions of the camera or software program.

noise
The digital equivalent of grain. It is often caused by a number of different factors, such as a high ISO setting, heat, sensor design, etc. Though usually undesirable, it may be added for creative effect using an image-processing program. See also, chrominance noise and luminance.

overexposed
When too much light is recorded with the image, causing the photo to be too light in tone.

perspective
The effect of the distance between the camera and image elements upon the perceived size of objects in an image. It is also an expression of this three-dimensional relationship in two dimensions.

pixel
Derived from picture element. A pixel is the base component of a digital image. Every individual pixel can have a distinct color and tone.

plug-in
Third-party software created to augment an existing software program.

polarization
An effect achieved by using a polarizing filter. It minimizes reflections from non-metallic surfaces like water and glass and saturates colors by removing glare. Polarization often makes skies appear bluer at 90 degrees to the sun. The term also applies to the above effects simulated by a polarizing software filter.

Program mode
In Program exposure mode, the camera selects a combination of shutter speed and aperture automatically.

rear curtain sync
A feature that causes the flash unit to fire just prior to the shutter closing. It is used for creative effect when mixing flash and ambient light.

resolution
The amount of data available for an image as applied to image size. It is expressed in pixels or megapixels, or sometimes as lines per inch on a monitor or dots per inch on a printed image.

B mode

d, Green, and Blue. This is the color
odel most commonly used to display color
nages on video systems, film recorders,
.nd computer monitors. It displays all visible
colors as combinations of red, green, and
blue. RGB mode is the most common color
mode for viewing and working with digital
files onscreen.

sharp

A term used to describe the quality of an
image as clear, crisp, and perfectly focused,
as opposed to fuzzy, obscure, or unfocused.

shutter

The apparatus that controls the amount of
time during which light is allowed to reach
the sensitized medium.

Shutter-priority mode

An automatic exposure mode in which you
manually select the shutter speed and the
camera automatically selects the aperture.

slow sync

A flash mode in which a slow shutter speed
is used with the flash in order to allow low-
level ambient light to be recorded by the
sensitized medium.

small-format sensor

In a digital camera, this sensor is physically
smaller than a 35mm frame of film. The result
is that standard 35mm focal lengths act like
longer lenses because the sensor sees an
angle of view smaller than that of the lens.

stop down

To reduce the size of the diaphragm opening
by using a higher f/number.

stop up

To increase the size of the diaphragm open-
ing by using a lower f/number.

strobe

Abbreviation for stroboscopic. An electronic
light source that produces a series of evenly
spaced bursts of light.

synchronize

Causing a flash unit to fire simultaneously with
the complete opening of the camera's shutter.

USB

Universal Serial Bus. This interface standard
allows outlying accessories to be plugged
and unplugged from the computer while it
is turned on. USB 2.0 enables high-speed
data transfer.

Index